Smoke Damage

VOICES FROM THE FRONT LINES OF AMERICA'S TOBACCO WARS

Michael Schwalbe

Borderland Books

Published by Borderland Books, Madison, WI

www.borderlandbooks.net

First Edition
Printed in Canada

Designed and typeset by Jane Tenenbaum

Publisher's Cataloging-In-Publication Data
(Prepared by The Donohue Group, Inc.)

Schwalbe, Michael, 1956–
Smoke damage : voices from the front lines of America's tobacco wars / Michael Schwalbe.

p. : ill. ; cm.

Includes bibliographical references.
ISBN: 978-0-9815620-8-7

1. Tobacco smoke—Toxicology. 2. Tobacco—Physiological effect.
3. Tobacco use--Health aspects. 4. Cigarette smokers—Health and hygiene.
5. Smoking—Complications. 6. Tobacco use—United States—History. I. Title.

RA1242.T6 S39 2011
613.85 2010933796

Contents

Introduction

WHEN SIX TEENAGERS DIE IN A HEAD-ON COLLISION, OR TWENTY-NINE MEN DIE IN A MINE EXPLOSION, we can empathically experience grief and loss. We know and feel that something terrible and tragic has happened and that we may need to act to prevent another occurrence. On a small scale, we can be touched and moved by the suffering of others.

But how can we feel fifty thousand dead in a battle? Or fifty million dead in a world war? We can't. Such figures, as Erich Fromm argues in *The Sane Society*, become numbing abstractions. All we can do is to confront individual suffering and then magnify it to the extent that imagination will allow.

The figure that concerns me here is also numbing: 440,000 — the approximate number of deaths attributable to tobacco-related disease every year in the United States.[1] Globally, the annual figure is six million. It's hard to feel what such numbers mean, or why they demand a greater response than they have yet received, without confronting individual cases.

The impetus for *Smoke Damage* was my father's case. Born in 1932, he began smoking when he was thirteen. When he cleaned his grandfather's tavern on Sunday mornings, he could find enough long butts to last him all week. By sixteen he was hooked. When he got out of the army in 1955, the year before I was born, he was up to two packs of unfiltered Camels a day. At that time, 54% of adult men in the U.S. smoked.[2]

In the fall of 1996, as he approached his 64th birthday, my father's morning cough no longer abated after a few minutes. My mother urged him to see a doctor. When he finally went for a check up, the X-rays showed a six-centimeter spot on his right lung. "I see about 150 of these a year," the doctor told my parents. "It's a typical tobacco tumor."

After surgery to remove the tumor, my father took chemotherapy and radiation. According to my mother, he considered forgoing treatment after the surgery. He went ahead with it, she said, only because he thought it might keep him around long enough that his grandchildren would remember him. He hoped for one more Christmas.

There was pain and fatigue from the radiation, then nausea, disorientation, and neuropathy from the chemo. After his last chemo session, the doctors said my father's blood tests looked good. But he never recovered from the strain of the surgery and adjuvant treatment. Later, the docs suspected that cancer cells had spread to his adrenal glands. He died in April, 1998, a 65-year-old man who looked to be a wizened ninety.

My mother bore the burden of care. She drove my father to and from his medical appointments. She cleaned and

cooked and took over the outside chores my father could no longer do. Toward the end, she washed him and helped him get to and from the bathroom, picking him up when he fell. She dealt with the frustrations and withdrawal of an angry, dying man.

The story of my father's death from lung cancer is not unusual. Every year in the U.S. there are about 160,000 lung cancer deaths, 87% of which are caused by smoking. Each death creates waves of suffering that extend beyond the sick and dying. Life partners lose life partners, children lose parents, grandchildren lose grandparents, friends lose friends. It is not only the loss that is painful but also the protracted, wracking decline that often precedes it.

Watching this process unfold led me to think of documenting the experiences of "tobacco widows." I wanted to more fully expose the human costs of tobacco-related disease, especially the costs borne by family caregivers and by the bereaved, that are not captured by statistics. As I thought about who should be included in a full accounting, I began to grasp the enormity of how we are affected by tobacco-related disease.

Tobacco users who die prematurely are obviously affected, as are their family members, friends, caregivers, and employers. But even if we multiply 440,000 by two, or six, or ten, the consequences are still understated. There are more categories of people, not just sufferers, survivors, and widows, whose lives are affected by tobacco-related disease.

There are, for instance, health educators who try to reduce tobacco-related disease through classroom programs and media campaigns. There are activists who fight to change public policy. There are researchers who study tobacco-related disease from the genetic level to the global level.

There are legislators who stake their political careers on passing tobacco-control and smokefree air laws. There are lawyers who take on tobacco companies in court. And there are farmers who quit growing the crop because they don't want to contribute to the massive harm it causes.

The experiences of people in all of these categories are important for understanding the impact tobacco-related disease has on our society. Death by tobacco might be the culmination of the plot, but it is not the whole story. So I gathered accounts from disease sufferers/survivors, widows (metaphorically construed; not just women who've lost spouses), tobacco-control educators and activists, researchers, legislators, lawyers, and former tobacco farmers.

Between September 2003, and July 2007, I interviewed and photographed forty-six people. The core of *Smoke Damage* consists of the photographs and excerpts from the interviews. I originally planned to interview forty-four people, each person standing for ten thousand deaths in the United States every year. I added an additional interview (which involved two people) to represent the annual global death toll.

In selecting excerpts from the interviews, some of which were hours long, I sought to highlight what struck me as most illuminating. I also tried to minimize redundancy across the interview segments and to include material that reflected the diversity of experience among people in the same category. People's words from the interviews are reported as they spoke them, with some clean-up of grammar and false starts. I take responsibility for any errors of transcription and for the loss of nuance that is inevitable when excerpting from longer texts.

The photographs are offered as further testimony to the reality of tobacco-related disease. Individuals disappear into statistics, which is perhaps why statistics can leave us cold: they show us no fellow creature with whom to empathize. Photographic portraits, in contrast, affirm the existence of real people and invite connection. My hope is that the photo-

graphs in *Smoke Damage* will function in this way, making it easier to feel the meaning of numbers that might otherwise exceed our emotional grasp.

A PROFITABLE EPIDEMIC

Social behavior is implicated in all epidemics and pandemics. Disease transmission occurs because of who interacts with whom. Vulnerability to disease is linked to nutrition, stress, and prevention — all of which are shaped by economic forces. Likewise, disease agents and vectors (e.g., swamps, mosquitoes, plasmodium parasites) may continue to exist mainly because of the political powerlessness of those who are at risk.

All disease patterns are thus a result of both natural and social causes. Tobacco-related disease is a result of the body's vulnerability to the carcinogens and other toxins present in tobacco (or given off when tobacco is burned). It is also a result of the brain's susceptibility to nicotine addiction. If not for these biological factors, there would be no epidemic of tobacco-related disease.

Tobacco-related disease is not, however, the result of exposure to a naturally occurring, invisible disease agent from which it is hard to protect ourselves. It is unlike flu, cholera, plague, and other diseases that can kill on an equally large scale. In the case of tobacco-related disease, the causes are, for all important purposes, entirely social, if we understand the social to include the economic and political.

The problem, to state it plainly, is that powerful corporations, seeking profit, strive mightily to expose millions of people to a manufactured disease agent, the effects of which are well known. At the most basic level, there is no scientific or sociological mystery here. Tobacco-related disease is caused by the imbalance of political and economic power between tobacco corporations (which exist as doleful accidents of history) and nearly everyone else.

As others have pointed out, if cigarettes, the most widely used tobacco product, were invented today, they would not be allowed to come to market. The reason is simple: cigarettes, if used as intended, will cause premature death among half of all lifetime smokers. It would be fair to call such a product *defective*.

It would also be fair to call the effort to cover up the product's defects *immoral* and, as an act of conspiracy, *criminal*. Whistleblowers and documents pried loose through lawsuits have established beyond a doubt that the tobacco industry engaged in such a cover-up for decades. That this concealment, which contributed to millions of deaths over a period of decades, is immoral, should be so obvious as to require no further comment.

The tobacco industry's criminality is not in doubt, either. This has been established over and again, most notably in the Engle case and in the U.S. Department of Justice's suit against the industry for racketeering. In the class-action Engle case in 2000, a Florida jury found that tobacco companies had lied about the harmful and addicting effects of cigarettes, and thus were liable for billions of dollars in compensatory and punitive damages. Although the class certification was later revoked on appeal, thus annulling the damage awards, the factual determinations of liability and guilt were affirmed, and suits are now being won on an individual-by-individual basis.[3]

The Department of Justice suit was brought in 1999, reached trial in 2004, and was concluded in August 2006. At the end of the trial, U.S. District Court Judge Gladys Kessler ruled that the major U.S. tobacco companies were guilty of

violating the Racketeer Influenced Corrupt Organizations (RICO) Act.[4] Lest my criticism of the tobacco industry seem too strident, it is worth quoting parts of Kessler's decision:

> [This trial] is about an industry that survives, and profits, from selling a highly addictive product which causes diseases that lead to a staggering number of deaths per year, an immeasurable amount of human suffering and economic loss, and a profound burden on our national health care system. Defendants have known many of these facts for at least 50 years or more. Despite that knowledge, they have consistently, repeatedly, and with enormous skill and sophistication, denied these facts to the public, to the Government, and to the public health community. Moreover, in order to sustain the economic viability of their companies, Defendants have denied that they marketed and advertised their products to children under the age of eighteen and to young people between the ages of eighteen and twenty-one in order to ensure an adequate supply of "replacement smokers," as older ones fall by the wayside through death, illness, or cessation of smoking. In short, Defendants have marketed and sold their lethal product with zeal, with deception, with a single-minded focus on their financial success, and without regard for the human tragedy or social costs that success exacted. (pp. 3–4)

> [A] word must be said about the role of lawyers in this fifty-year history of deceiving smokers, potential smokers, and the American public about the hazards of smoking and secondhand smoke, and the addictiveness of nicotine. At every stage, lawyers played an absolutely central role in the creation and perpetuation of the Enterprise and the implementation of its fraudulent schemes. They devised and coordinated both national and international strategy; they directed scientists as to what research they should and should not undertake; they vetted scientific research papers and reports as well as public relations materials to ensure that the interests of the Enterprise would be protected; they identified "friendly" scientific witnesses, subsidized them with grants from the Center for Tobacco Research and the Center for Indoor Air Research, paid them enormous fees, and often hid the relationship between those witnesses and the industry; and they devised and carried out document destruction policies and took shelter behind baseless assertions of the attorney client privilege. (p. 4)

> Put more colloquially, and less legalistically, over the course of more than 50 years, Defendants lied, misrepresented, and deceived the American public, including smokers and the young people they avidly sought as "replacement smokers," about the devastating health effects of smoking and environmental tobacco smoke, they suppressed research, they destroyed documents, they manipulated the use of nicotine so as to increase and perpetuate addiction, they distorted the truth about low tar and light cigarettes so as to discourage smokers from quitting, and they abused the legal system in order to achieve their goal — to make money with little, if any, regard for individual illness and suffering, soaring health costs, or the integrity of the legal system. (pp. 1500–1501)

Considering the consequences of tobacco company behavior — many millions of premature deaths related to smoking — it is hard to imagine any other business entities more deserving of the label "corrupt organizations."

Pointing out the industry's guilt and deceit in relation to tobacco-related disease thus should be uncontroversial.[5] Yet to do so is to invite the charge that one is calling tobacco users "dupes" and failing to value "individual choice." That such charges are taken at all seriously is testament to the power of the industry's propaganda. The ideas that smokers freely choose to use tobacco and that industry critics are puritanical nannies or "health nazis" were invented in the industry's public relations laboratories to thwart passage of smokefree air laws.

In fact, 30% of smokers start before they're fourteen, 80% start before they're eighteen, and 90% start before they're twenty. Smoking, in other words, is a practice adopted almost exclusively by adolescents. The industry knows this. Which is why it spends $12.8 billion a year on marketing, much of which subtly exploits adolescent insecurities, implying that smoking is a sign of independence, sexiness, and adult sophistication.[6]

Once marketing succeeds in getting young people to try tobacco products and keep using for a while, nicotine does the rest. Once a user's brain chemistry has been sufficiently altered by nicotine, repeated dosing is necessary for the user to feel normal. Long after adolescent insecurities have been resolved, the addiction remains. The image of "getting hooked" is apt — the barb being embedded in both brain and pocketbook.

So, to claim that smoking is a matter of choice (as if rational adults consider a range of stress-reduction techniques and then decide that smoking is their best bet) is naive or dishonest. The truth is that smoking is a marketing-driven addiction that begins in adolescence. Of course adults can quit, but to do so they must overcome physical compulsions and social habits the strength of which cannot be foreseen by teenagers. That's why adults who want to quit — about 70% of all smokers — struggle to do so, and must try, on average, about six times before they succeed.

What's different, then, about tobacco-related disease is not just the immense death toll. Unlike diseases caused by natural pathogens or the body's inevitable decline, tobacco-related disease exists only because we allow profit-seeking corporations to sell products that have no social benefit. What this means is that, in principle, the epidemic of tobacco-related disease is entirely preventable. We would just have to decide to rid ourselves of the pathological economic entities that are its source.

IS THE PROBLEM BEHIND US?

No one to whom I spoke about this project denied the seriousness of the tobacco problem. Yet several times I heard some version of the following from friends and colleagues: "*Isn't the problem largely behind us now? Smoking rates are declining. So are lung cancer rates. Most cigarette advertising has been curtailed. Pretty soon nobody will smoke.*" If only this were true.

Yes, adult smoking rates in the U.S. have declined dramatically since the mid-1960s. At that time, about 42% of all adults smoked.[7] The rate today is hovering around 20%. Owing to this decrease in smoking rates and to better screening, lung cancer death rates have gone down slightly. This is progress worth celebrating.

Limits on advertising, starting with the elimination of television ads in 1971, are also real progress. The 1998 Master

Settlement Agreement imposed further restrictions, especially on ads aimed at teens. In 2009, the Family Smoking Prevention and Tobacco Control Act, which gave the FDA a degree of regulatory power over the tobacco industry, put more limits on advertising in places where it is likely to be seen by young people.

Progress is also evident in our knowledge of how to reduce smoking. We know what works: higher taxes, smokefree air laws, employer and insurance company support for cessation programs, comprehensive advertising bans, and education that exposes not only tobacco's toxicity and addictiveness but also the deceit and manipulation of the industry.

Because we are less awash in tobacco advertising than we used to be; because headlines have touted lower smoking rates; because there are now as many former smokers as current smokers; because more people may be using covert tobacco products (snus, orbs) in public; because smoking indoors is banned in many places; and because it's possible — depending largely on one's social class — to almost entirely avoid secondhand smoke, it's not surprising that some people imagine that the problem of tobacco-related disease is behind us, or will be soon.

In fact, it's likely to get worse.

Lung cancer is only part of the picture. The overall disease rolls will grow as baby boom smokers reach late middle age and develop emphysema, heart disease, atherosclerosis, stomach cancer, laryngeal cancer, esophageal cancer, cervical cancer, pancreatic cancer, bladder cancer, and other ailments linked to smoking. It's also sobering to note that more cigarettes are manufactured and consumed today — about six trillion per year worldwide — than ever.

Even in the United States, where conditions have improved in the ways noted earlier, there are still 46 million smokers. If current patterns hold, about half of this group will die prematurely from tobacco-related disease. There are another 45 million *ex*-smokers who remain at elevated risk for lung cancer. And while teen smoking rates have indeed gone down since 1997, still about 3,500 teens try their first cigarette *every day*. Of these, about 1000 will become daily smokers before they finish high school. Rates of smokeless tobacco use are also up among older teens.

Tobacco companies have been brought to heel somewhat, but they remain powerful because of the vast resources at their disposal.[8] These resources are not only monetary. They also include small armies of people with expert skills in marketing, lobbying, and lawyering. If there is a way to weaken or evade a piece of regulation, tobacco company minions will find it.

Perhaps most pernicious are the new marketing tactics devised in response to advertising restrictions. For example, "light and luscious" Camel No. 9s, a new brand introduced in 2007, is stylishly packaged to appeal to teen girls. Point-of-sale promotions are also ramped up in convenience stores most likely to be patronized by teens. And while "light" and "mild" can no longer be used to imply that some cigarettes are safer than others, marketers now try to convey the same message by color-coding the packs.

The industry has responded to the more restrictive smoking environment by developing covertly-usable products, such as snus (small tobacco-filled teabags that are tucked between cheek and gum) and orbs (candy-like pellets that dissolve in the user's mouth). While such products might be less harmful than cigarettes, they are still nicotine delivery devices, and so they retain the potential to hook teen users. Such products are also likely to prolong addiction among smokers who might otherwise quit because smokefree air laws make it impossible or inconvenient to smoke.

The good news is that since 1997, teen smoking rates have gone down, leveling-off now at just under 20%. This

leveling-off is a worrisome development, however, in view of the enduring vulnerability of adolescents and the industry's ability to circumvent partial marketing bans. Here again we can expect, among teens who become long-term smokers, millions of new cases of cancer and other tobacco-related diseases in the next twenty to thirty years.

If we continue to use the methods that we know are effective in reducing smoking, *rates* of tobacco-related disease should continue to decline in the United States (and Western Europe). Around the world, however, in countries where smoking is more prevalent today than it was in the early 1960s in the U.S., rates of tobacco-related disease are going to skyrocket. On a global scale, what looms is a health catastrophe. Consider that in China alone there are more male smokers (311 million) than there are people in the United States.

As if the current worldwide annual death toll of six million were not catastrophic enough, projections are that by 2020 the annual toll will be seven million, and that by 2030 it will be eight million. These projections assume that rates of tobacco use stay constant. If rates go up because the industry succeeds in addicting new populations (e.g., Asian women), then the death toll will be higher. About 100 million people died from tobacco-related disease in the 20th century. The figure for the 21st century, without dramatic changes in policy, could reach one billion.

To imagine that the problem is behind us thus requires selective perception. Among the educated and affluent in North America, progress has been good. Less than 6% of people with graduate and professional degrees smoke, and most people in this highly-educated group work in smokefree environments. This is perhaps why my friends and colleagues and other upper-middle-class people overestimate how far we've come in solving the tobacco problem.

But when looking beyond privileged groups, the view is less bright. The smoking rate among high school dropouts is almost three times the rate among college graduates. Rates also vary across states, from a high of 26.6% in West Virginia to a low of 9.2% in Utah (which suggests how much more could be done to reduce smoking rates everywhere).[9] Among adults living in poverty, the rate is over 30%. And if we look beyond the United States, especially at countries in Eastern Europe and Southeast Asia, it is clear that the worst is yet to come.

The problem of tobacco-related disease is clearly not solved, not over, not "behind us" for the 440,000 who die every year in the United States, nor for their families, friends, caregivers, and employers. Nor for the global six million and the millions more connected to them. The relative handful of people in *Smoke Damage* stand as reminders of the problem's currency and of what remains to be done to solve it.

A BRIEF TOBACCO MEMOIR

My parents were smokers, as were most of their friends, as was nearly every adult in my extended, working-class family. My exposure to nicotine thus began *in utero*. For the first eighteen years of my life, until I left home for college, I was exposed to secondhand smoke on a daily basis. Despite this extensive exposure, I am, by epidemiological designation, a person who has never smoked.

Except on three occasions. The first was during the summer after I turned thirteen. A buddy stole a pack of cigarettes from the grocery store and three of us polished them off in an afternoon, trying out various cigarette-enhanced macho poses. An hour before dinner I was puking in the weeds beside our garage. I was never again tempted to smoke a cigarette.

The second time was during my first year of college. While drinking beer and shooting pool, a dorm buddy offered me a Swisher Sweet (a small, mild cigar). I don't recall how many of them I smoked that night — maybe only two. What I recall is waking up hungover the next morning, with the inside of my mouth feeling like it had been coated with paste made from campfire ashes. That experience extinguished my interest in cigars.

A year later I got the idea to try a pipe. Maybe I liked the smell, or the intellectual image. So one time, while driving home from college, I tried to pack and light a cheap drugstore pipe. It was an awkward process and I couldn't keep the tobacco lit. After the pipe went out yet again, I looked at myself and laughed. Why did I think this was a smart thing to do? The pipe and what was left of the tobacco went into the trash at the next gas station.

I'm lucky that I had no experience in using tobacco that held any appeal for me, beyond a few moments of foolishness. Fortunately, too, none of my close friends in high school were smokers. It was an era when the smart kids — in contrast to the gearheads, dopers, greasers, and burnouts — signified their smartness in part by not smoking. Looking back, it was not a bad mark of distinction.

It was also an era of clever anti-smoking ads on TV. I still recall the ad in which a black-clad gunslinger enters a bar, cigarette dangling between his lips, and calls out a non-smoking cowboy. Midway through his challenge, the bad guy starts coughing, eventually collapsing in a hacking heap, while the good guy scornfully pushes him aside and walks out. It was a good ad for boys because it undercut the industry's efforts to link smoking to masculinity.

The adults in my family generally admitted that smoking was bad for them. Between such frank admissions and the anti-smoking ads on TV, I had no doubt that pestering my parents to quit was the right thing to do. My nauseating brush with cigarettes probably added to my zeal, which manifested in various ways. On my mother's next birthday I gave her an ashtray. She recalls that it was about six inches in diameter, made of cast plaster with a faux-antique finish. On one rim, opposite the cigarette notch, rested a skeleton.

A few years ago my mother reminded me that what might be called my first act of civil disobedience involved smoking. From the time I was in third grade, she would send me to the drugstore with two dollars and a note that said, "Please send two packages of Vantage cigarettes." Back then, buying cigarettes for my mom was as unremarkable as buying milk or bread.

But one day — my mother remembers that I was around eleven — I refused to do it, on the grounds that smoking was bad for her and it was wrong to enlist me in causing the harm. To my surprise, she let me off the hook and never asked me to buy cigarettes again. My withdrawal from the cigarette trade of course led to no decrease in consumption, since the courier role simply shifted to my younger siblings. I wish it had occurred to me at the time that organized resistance might have made a difference.

Long after I left home, I continued to be exposed to secondhand smoke. Some exposure occurred in the company of friends who smoked, but most of it was in bars, as both a patron and, for a few years, a bartender. Having grown up in a smoke-filled house, it didn't occur to me to make an issue of secondhand smoke elsewhere. It was completely normalized.

I did, however, occasionally make smoking an issue with friends. I relished pointing out, to people who were otherwise rational and frugal and concerned about eating right, the irrationality of maintaining a costly, health-damaging habit.

Not understanding how addiction could trump reason, I didn't understand why my logically irrefutable harangues weren't more effective, though I did get one graduate school girlfriend to quit smoking.

In 1983, I moved from Washington to California and, owing mainly to new domestic and work arrangements, left behind the bar culture that had been part of my life since I was in high school. No longer spending time in bars, I no longer spent much time in smoke. This made smoke all the more noticeable and irritating when I visited family in Wisconsin twice a year.

Teaching a social epidemiology course at UC–Riverside in 1985 also forced me to look at the "tobacco problem" in a new way. A major premise of the course was that patterns of disease can be explained only by looking at them in cultural, political, and economic context. Viewed in these terms, the tobacco problem is not merely one of individuals making bad choices. It's a problem rooted in the maldistribution of power to shape culture and public policy.

I saw this even more clearly two years later when I moved to North Carolina. The uncritical thrall in which the tobacco industry held the state legislature, the local media, and my employer, North Carolina State University, disgusted me.[10] It was nothing less, as I saw it, than economically coerced collaboration with drug dealers. The popular rejoinder, woven into the cultural DNA of the state, was that tobacco was a "legal product" and therefore not like peddling drugs. This struck me as the kind of morally vacuous argument that might have been made, once upon a time, in defense of other legal arrangements, such as slavery.

My grandmother's death in 1988 also affected my thinking about tobacco. The tumor on her right lung came as a surprise, because she was one of the few non-smoking adults in the family. She did, however, live with a son and daughter who smoked, and she had been exposed to secondhand smoke most of her life.

The causal effect of this exposure was noted by my grandmother's doctor, who advised her, following radiation treatment for the tumor, to stay away from smoke. But the old farmhouse she shared with my aunt and uncle was small and poorly ventilated. Her bedroom door was a curtain on a rod. And so it was impossible for her, short of going outside, to escape the smoke.

What struck me was that neither my aunt or uncle, as far as I could tell, tried to quit smoking during this time. Nor did my mother refrain from smoking when she visited. As my grandmother was dying, the smoke in the house was as thick as ever. I saw that the power of nicotine addiction could override not only reason but also love for a parent.

Three years later, the uncle who lived with my grandmother died of cancer at age 59. It began in his prostate and spread to his spine, so I didn't connect it to his years of heavy smoking.[11] He had had a heart attack a few years earlier, and there is little doubt that smoking was a contributing factor. The aunt who lived with my grandmother also died from cancer. Hers began in the lungs and spread to the liver and spine. In the last few years before her death in 2009 at age 67, she was nearly immobilized by asthma and emphysema.

In January of 1993, two years after my uncle died, my father had a heart attack at work. He was carrying a coil of wire up a ladder when he felt a pain in his chest. He backed down and nearly fainted as he stepped off the ladder. Two co-workers helped him to the maintenance office of the foundry. After a glass of water and a few minutes' rest, my father declared himself ready to get back to the shop floor.

Fortunately, my father's boss recognized the symptoms and sent him to the hospital. As it turned out, the heart

attack caused only minor damage. The surgeon who later performed an atherectomy to scour the plaque from my father's cardiac arteries told him that the problem was caused by smoking. "If you don't quit smoking, you're committing suicide," was how my mother summed up the doctor's message.

My father seemed to hear it. He quit smoking, and so did my mother. It was a good thing, I said to my father when I spoke to him on the phone, that he'd gotten the proverbial wake-up call in time to make changes. I also said it was good that he'd save money now that he wasn't spending it on cigarettes. I tried to affirm his identity as an ex-smoker. But the changes didn't last. Within a few months he was sneaking out to the garage to smoke. Years later, after he died, we found cigarettes hidden in his fishing creel.

When one of my sisters told me he was smoking again, I was angry. It seemed to me that he was choosing to abandon us, as surely as if he were packing a suitcase and loading the car. Did it mean nothing to him that we, his five children, said how much we wanted him to be around for many more years? For us, I thought, he should have found the strength to quit.

I didn't know it at the time, but my father's relapse wasn't unusual. About half of heavy, long-term smokers keep smoking even after a life-threatening episode related to their tobacco use. The stress and depression that often accompany a debilitating illness later in life make relapse all the more likely. In retrospect, I should have had more compassion for his struggle and encouraged him to quit as many times as necessary to make it stick.

My mother managed to stay quit. When I next visited, after not seeing her for a year, I was amazed when she met me at the door. She had gained weight — thirty pounds she said — but looked ten years younger. She exuded energy that I hadn't seen in years. (The extra pounds later disappeared and my mother is, at this writing, seventy-six and doing fine.) Seeing my mother's transformation made me all the sadder about what my father hadn't been able to do.

About five years after his heart attack and resumption of smoking, my father died of lung cancer. Altogether, nine members of my family — my father and his father, my maternal grandmother, four aunts and two uncles — have died from or suffered from tobacco-related diseases: heart attacks, cancer, emphysema, and atherosclerosis.[12] It pains me to think that several family members of my generation might end up adding to that number.

Until recently, I thought that my family's tie to tobacco was limited to addiction, consumption, and death. Tobacco, I thought, was grown in the South, and so what could my Upper Midwest family have had to do with it? When my mother sent me an old family photo for digital restoration, I asked why my great aunt Rose was standing in a tobacco field. "She was helping aunt Alma and her husband harvest their tobacco," my mother explained. "They grew cigar wrap on a farm out near Viroqua in the 1930s and 40s."

When I think of all those who depend on income or taxes generated by tobacco; when I think of all the current and former tobacco users in the world; when I think of all the tobacco widows; when I think of all who have fought to reduce tobacco's harms, I wonder if anyone is untouched. What other commodity, besides oil, reaches as deeply into the social body? I wonder, too, how long it will take to extricate ourselves.

In the years since my father's death, in addition to undertaking this project, I have written op-eds exposing the tobacco industry's bogus overhaul of its public image, criticizing my university's addiction to tobacco money, supporting the effort to pass a smokefree air law in North Carolina, and arguing for FDA regulation of tobacco.[13] My partisanship in

these matters is driven not only by science and moral principle. I am also trying to relieve the weight on my heart and to reduce the number of people who will have to bear a similar weight in the future.

THE UPSHOT

Almost everyone knows that "smoking is bad for you." Although it resounds loudly here, the purpose of *Smoke Damage* is not merely to repeat this message. Certainly, one purpose is to show, in concrete terms, *how* tobacco-related disease changes people's lives for the worse, causing not just debilitation and premature death but also emotional suffering for those who are connected to tobacco users. If this information keeps some readers from smoking or leads others to quit, then *Smoke Damage* will have accomplished something useful.

But I hope also to incite other forms of action. Because the tobacco industry still has a great deal of power to influence politicians, there must be strong popular support for policies such as higher excise taxes on tobacco products, smokefree air laws, and comprehensive advertising bans. In documenting the human costs of tobacco addiction, *Smoke Damage* shows why these policies are important, not only in the U.S. but around the world. There is also information here that will equip readers who want to get involved and want to press elected officials to do the right thing (see Resources on page 111).

While I hope *Smoke Damage* induces compassion for those who have suffered because of tobacco-related disease, I am aiming for a stronger emotional response. When I interviewed Matt Myers, president of Campaign for Tobacco-Free Kids, he spoke of his experience when leading a Federal Trade Commission investigation of the tobacco industry in the early 1980s. "This is one of those issues," he said, "where the more you learn, the angrier you get." If readers of *Smoke Damage* come away understanding why that anger is justified, and feeling it, I would count it as further evidence of the book's success.

Taking a longer view, I think this book will have documentary value when historians of public health study the epidemics of tobacco-related disease in the 20th and 21st centuries. How could it have been the case (I can imagine them thinking) that democratic societies with so much scientific knowledge of disease allowed these epidemics to occur? This question doesn't yet provoke the incredulity it should. When it finally does, perhaps the testimony in *Smoke Damage* will help explain how it happened that for so long we allowed millions to die for the profit of a few.

NOTES

1. The Centers for Disease Control and Prevention estimate that 443,000 deaths per year in the United States are caused by smoking and by exposure to secondhand smoke. Altogether, tobacco-related diseases account for 18–20% of annual mortality in the United States. For a summary, see http://www.cdc.gov/tobacco/data_statistics/fact_sheets/health_effects/tobacco_related_mortality/#tobacco. For more detailed analyses, see Thun, M. J., Apicella, L. F., and S. J. Henley, "Smoking vs. Other Risk Factors as the Cause of Smoking-Attributable Deaths," *Journal of the American Medical Association* 284, no. 6 (2000); and Mokdad, A. H., Marks, J. S., Stroup, D. F., and J. L. Gerberding, "Actual Causes of Death in the United States, 2000," *Journal of the American Medical Association* 291, no. 10 (2004). Other health statistics reported here are from the third edition of *The Tobacco Atlas* (http://www.tobaccoatlas.org/), and from the websites of the Centers for Disease Control and Prevention (http://www.cdc.gov/tobacco/index.htm), the Campaign for Tobacco-Free Kids (http://www.tobaccofreekids.org/index.php), the World Health Organization (http://www.who.int/topics/tobacco/en/), and the American Cancer Society (http://www.cancer.org/docroot/ped/ped_10.asp).

2. See "Tobacco Use: United States, 1900-1999," *Journal of the American Medical Association* 282, no. 23 (1999). Historical trends in tobacco use in the United States are also reviewed in Allan Brandt's *The Cigarette Century* (Basic, 2007). Brandt's book and Richard Kluger's *Ashes to Ashes* (Vintage, 1996) are the essential sources on the history of the tobacco industry and its public health opponents in America. See also the sources listed in note 3.

3. For background on the legal battles that have been waged against the tobacco industry, see Carrick Mollenkamp, et al., *The People vs. Big Tobacco: How the States Took on the Cigarette Giants* (Bloomberg, 1998); Peter Pringle, *Cornered: Big Tobacco at the Bar of Justice* (Henry Holt, 1998); Michael Orey, *Assuming the Risk: The Mavericks, the Lawyers, and the Whistle-Blowers Who Beat Big Tobacco* (Little, Brown and Co., 1999); Dan Zegart, *Civil Warriors: The Legal Siege on the Tobacco Industry* (Delacorte, 2000); Michael Pertschuk, *Smoke in Their Eyes* (Vanderbilt University Press, 2001); and David Kessler, *A Question of Intent: A Great American Battle with a Deadly Industry* (Public Affairs, 2002).

4. The defendant tobacco companies appealed the decision, and as of summer 2010 the case appears to be headed for the Supreme Court. Detailed information about the Department of Justice case can be found at http://www.tobacco-on-trial.com/ and at http://www.justice.gov/civil/cases/tobacco2/index.htm. A summary of current litigation outcomes is available from the Tobacco Products Liability Project (http://www.tobacco.neu.edu/).

5. There is voluminous literature documenting the industry's deceit and illegal behavior. In addition to the sources mentioned previously, see Stanton Glantz, et al., *The Tobacco Papers* (University of California Press, 1996); Philip Hilts, *Smokescreen: The Truth Behind the Tobacco Industry Cover-Up* (Addison-Wesley, 1996); and David Michaels, *Doubt Is Their Product* (Oxford University Press, 2008).

6. Marketing includes more than advertising in mass media. Today, about three-fourths of the industry's marketing expenditures are for point-of-sale advertising, price discounts, two-for-one sales, and giveaways of promotional items (e.g., hats, lighters). The website of Campaign for Tobacco-Free Kids (http://www.tobaccofreekids.org/index.php) includes a wealth of information about how tobacco companies continue to market to young people, despite restrictions.

7. Smoking prevalence in the U.S. has always been higher among men. The rate for men peaked at 60% in 1959, dropped below 55% by the mid-1960s, and stands at 23.1% today. The rate for adult women peaked at about 34% in the mid-1960s and has fallen to 18.3% today. About half of the five-year gap in life expectancy between women and men is attributable to men's higher rates of death from tobacco-related diseases. See Ingrid Waldron, "Gender Differences in Mortality—Causes and Variation in Different Societies," in Peter Conrad (editor), *The Sociology of Health and Illness: Critical Perspectives* (Worth-St. Martins, 2005, 7th edition).

8. The tobacco industry continues to lobby against legislation that threatens its profits. Between 1997 and 2007, the industry contributed nearly $35 million to political candidates and PACs (*Tobacco Atlas*, 3rd ed., p. 60). Donations to charities, universities, minority-group support organizations, and other civic non-profits also constitute attempts to buy influence by cultivating goodwill. All of these expenditures are a tiny fraction of the industry's resources. As reported in *The Tobacco Atlas* (3rd ed., p. 50), the global tobacco market is valued today at about $380 billion.

9. These prevalence estimates are from the Centers for Disease Control and Prevention. In August 2010, Gallup-Healthways reported poll results from 2009 showing an adult smoking rate of 31% in Kentucky and West Virginia, a 13% rate in Utah, and a national average of 21%. States with the lowest average levels of formal education, lowest cigarette taxes, and weakest smokefree air laws have the highest rates of smoking. Utah's low rate is partly attributable to its high Mormon population and to Mormon teachings that discourage smoking.

10. In fairness to the North Carolina state legislature and to the local media, the situation is much better today. In 2009, the legislature passed a decent, if imperfect, smokefree air law, which was supported editorially by the state's major newspapers, the *Raleigh News & Observer* and the *Charlotte Observer*, among others. On the other hand, the legacy of tobacco's former champion in the U.S. Senate, Jesse Helms, has been carried on by two North Carolina senators who remain servants of the industry, Richard Burr (Rep.) and Kay Hagan (Dem.). Even Burr's Democratic challenger in the 2010 election, Elaine Marshall, said of tobacco, "I will fight tooth and nail any attempts to kill this important crop." In North Carolina, we still await the senator, or viable senatorial candidate, who will fight to prevent tobacco from killing nearly 14,000 of his or her constituents every year.

11. Until recently, smoking was not thought to be a risk factor for prostate cancer. This conclusion was based on research comparing smokers to non-smokers. The latest research looks at total amount of smoking (in "pack/years") and finds that the heaviest smokers have a 24–30% greater risk of *dying* from prostate cancer. The risk is further elevated (to 55%) if smokers with prostate cancer are also obese.

12. If I count my mother's breast cancer, the number is ten. In the case of breast cancer, however, the causal link is less certain. Early studies found no significant variation in incidence rates between women who smoked and those who did not. More recent studies have found that the risk of breast cancer increases as total lifetime exposure to smoke increases. See Johnson, Kenneth C., "Accumulating Evidence on Passive and Active Smoking and Breast Cancer Risk," *International Journal of Cancer* 117, no. 4 (2005); Croghan, Ivana T., et al., "The Role of Smoking in Breast Cancer Development: An Analysis of a Mayo Clinic Cohort," *The Breast Journal* 15, no. 5 (2009); Reynolds, Peggy, et al., "Passive Smoking and Risk of Breast Cancer in the California Teachers Study," *Cancer Epidemiology, Biomarkers & Prevention* 18, no. 12 (2009).

13. See "Time to Clear the Air," *Raleigh News & Observer*, January 11, 2009; "Empower the FDA to Regulate Tobacco," *Raleigh News & Observer*, April 6, 2008; "NC State's Tobacco Addiction," *Raleigh News & Observer*, December 19, 2005; "Healthier Appetites: Legislature Should Ban Smoking," *Raleigh News & Observer*, May 11, 2005; "Tobacco Still Spells Trouble," *Raleigh News & Observer*, August 2, 2004.

Portraits and Interviews

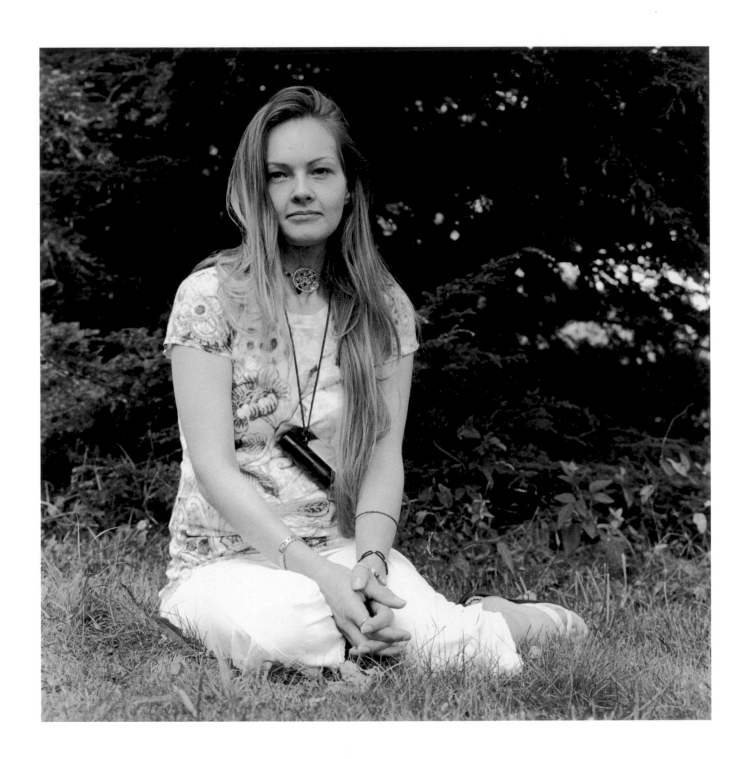

Reena Roberts

REENA ROBERTS WAS BORN IN 1979 AND BEGAN SMOKING WITH FRIENDS IN THE SCHOOL BATHROOM when she was in the 9th grade. By sixteen she was addicted, and by nineteen she was smoking almost two packs a day. At twenty-one, after being told for six months that she had "chronic laryngitis," she was diagnosed with throat cancer. Six months pregnant at the time, Roberts miscarried two days before the surgery that removed her vocal cords. She learned to speak with an electrolarynx by reading aloud from the Bible.

∽ ∾

Finally they sent me to the Baptist hospital in Winston-Salem [North Carolina]. They had people there who identify rare diseases and they wanted to know if I'd left the country, or if I'd been around any strange animals. They didn't know what was wrong. They had done like three or four biopsies and they were just cutting around in there on me. The cancer was so far behind where they were cutting that all they were getting was the infection. They weren't actually getting to the cancer. So they finally did another biopsy on me. When I saw the oncologist, he said, "Well, it's bad news." I knew then, when he walked in the door. I knew I was sick.

The first time I was conscious after the surgery and they let me go to the bathroom by myself, I looked in the mirror and I flipped out, and they put me out. I don't really remember much of my stay after that. They kept me really doped up. I don't remember exactly what I saw when I looked in the mirror, but my mom said that I was pulling my hair. They said that I kept mouthing that I was like a monster and I was yanking my hair out and trying to pull my bandages off.

It doesn't seem like a very big thing, smoking a cigarette, you know? Or it never did to me. And now I just — it's hard for me to even look in the mirror some days because this hole is always there. If I answer my phone and it's somebody who knows I talk with the electrolarynx, they won't hang up. When I'm in the store, people stare. I've got three kids, so I try to keep them under control. "Stop that. Get down. Don't do that. Don't touch that." And as soon as I say anything, wherever we are, everybody turns around to look at what the noise is.

With alcohol you know you can get arrested if you drink too much — you can get a DUI. And you know that too much alcohol does damage to your body. But you can smoke as much as you want. You can smoke as much as you want in a day and no one's going to say anything to you. No one's going to take away your cigarettes. I don't understand how they can make something that damages your body like that. They might as well make methamphetamines legal. I mean, that's honestly how I think about it. *Street* drugs are illegal. What's the difference between them and cigarettes? They're manufactured in a company. Is that the only difference? They both do just as much damage, yet one's illegal and one's limitless.

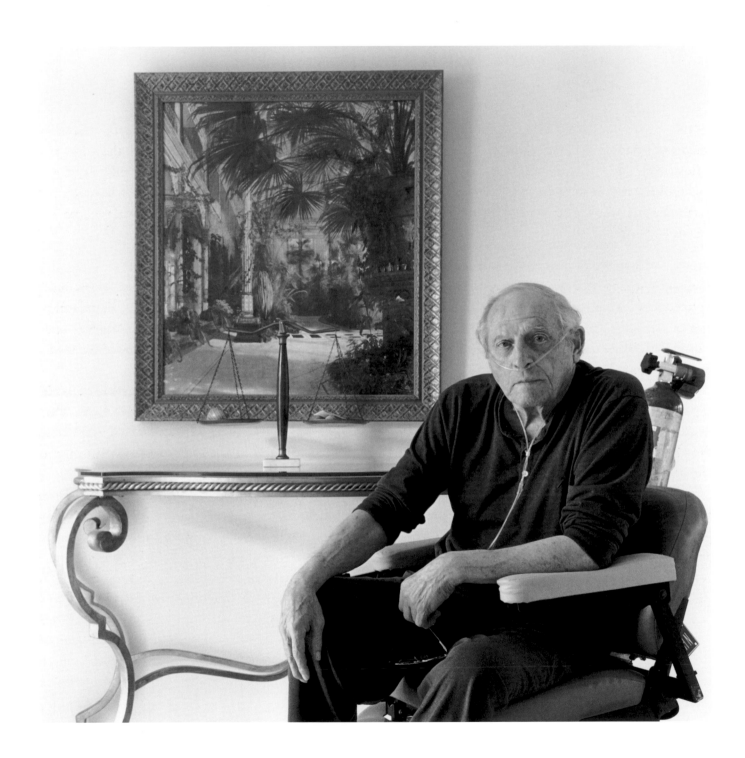

John Eastman

JOHN EASTMAN WAS BORN IN 1928 AND STARTED SMOKING WHEN HE WAS FOURTEEN. In the 1970s and 1980s, Eastman was a popular talk radio host in Tampa Bay, Florida. Emphysema ended his media career in the mid-1990s. In 1997 he sued the Philip Morris and Brown & Williamson tobacco companies, charging that they had lied about the harmful effects of cigarettes and the addictive power of nicotine. In April of 2003, he won a verdict that gave him $3.2 million after attorney fees. It was the first time Philip Morris had been forced to pay a judgment in an individual tobacco liability case. Eastman died in 2008.

❧ ❧

The reason I got into radio was because I was a lonely boy, from the days out in Iowa. I had a radio by my bed and I listened to radio. I listened to 50,000-watt stations like KDKA in Pittsburgh and WGM in Chicago, and they would carry a major orchestra — Tommy Dorsey, Glenn Miller, or somebody from some ballroom somewhere in America, and they were sponsored by a cigarette company, Chesterfield. There was the Lucky Strike "Hit Parade." All that, I listened. *That* was sophistication.

Every child looks across the street or over the hill to something new or better or more exciting. There's a world he's not a part of. When you can whistle in his ear about that, you're charming him with romance. Wherever it is that this person is standing while they're smoking the cigarette — it could be a local bar or a bridge in Paris — is romance. And all children are available to romance. Tobacco knows it, and they're romancing them, as they romanced me. They romanced me with Tommy Dorsey.

They've still got people smoking in the movies. Actors and tough guy detectives — people who look sophisticated. And the people smoking in the movies are romancing the kids who watch them. That's the only way they can get them in. They have to get them in the movie where the kid will see it. And the movie makers are taking the money because they need the money for the production of the movie or for their own greed, so they're romancing the kids. That's what makes them smoke. Nobody smokes for nutrition. They smoke for romance, in the head, in the mind. It's a big game. We fall in love. It can't be helped.

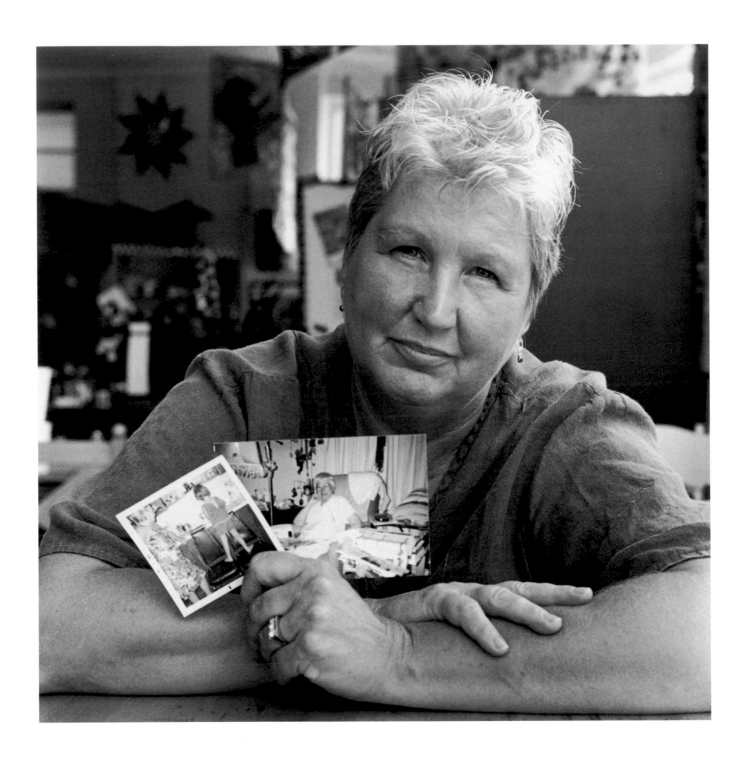

Monnda Welch

MONNDA WELCH'S MOTHER SMOKED FOR 40 YEARS BEFORE BEING DISABLED BY EMPHYSEMA. She spent the last 20 years of her life tethered to an oxygen machine, her grandchildren knowing her mainly as a sick shut-in. In 2004, Monnda Welch tallied the members of her working-class family who had died of tobacco-related disease: "An aunt, uncle, cousin, my husband's parents, my mother, another cousin, two more aunts. That's nine." Counting her ex-husband, who died of lung cancer caused by smoking, made it ten.

∾ ⌣

My mother started to get sick when I was in junior high school. She had a horrible cough, and I would say, "Why don't you stop smoking? You smoke and you cough. People who *don't* smoke *aren't* coughing. This is not rocket science!" She also started having frequent bouts of pneumonia. After high school, I went into the air force, and then came home and had my babies. And she was still smoking. And really sick, too. Pneumonia all the time. I would say to her, "Mom, this is my child. You *cannot* smoke and hold this child. You cannot even smoke in the same *room* as this child." See, I had some power then, because I had something that she wanted. So she wouldn't smoke if she was at my house or around my babies.

My mom was getting progressively sicker, to the point where she couldn't do as many things with us. I spoke to my 36-year-old son last week about this. I asked him, "Do you remember Nana when she wasn't sick?" He didn't think so. It was 1976 when she had to start using what she called her "breathing machine." My daughter Anna was born in 1972, so all she ever knew of her grandmother was when she was sick. I think my mother could look at my kids and know that she wasn't going to see them grow up.

I said to my son, "Smoking killed your father. It killed your grandparents. It killed your cousins. It killed your aunts and uncles. *Why* are you doing this?" And he said, between coughs, "I don't know, Mom, I like it." He started when he was sixteen and when he turned thirty he was starting to get sick. He'd get horrible coughs and colds and sinus problems. He's a carpenter, so they'd work outside, and for like three years in a row he was coming down with pneumonia. So finally he said, "That's it. I've had it. I'm quitting smoking." So he quit. Just like that. It's been three years now. He made a scrap book. He cuts out articles about tobacco, about people dying. Anything that shows the detrimental effects of tobacco, he'll put it in his scrap book. And if he's tempted to smoke, he'll go read those stories. A picture of his father is in there too.

When I was in China, I went through a cloisonné factory. Because I'm a metals artist, I'm very aware of the dangers of chemicals and other pollutants. I walked into this factory and I thought, My God, this is a time bomb! There's no ventilation. No protective clothing or masks. They're eating where they're working. And I said to my guide, "This is very dangerous. Don't they know how bad this is?" I said this like five times, and finally he said to me, "We have lots of people." And the smoking there was just terrible. So there's a lot of greed driving economic systems everywhere. Why else would they still be making cigarettes?

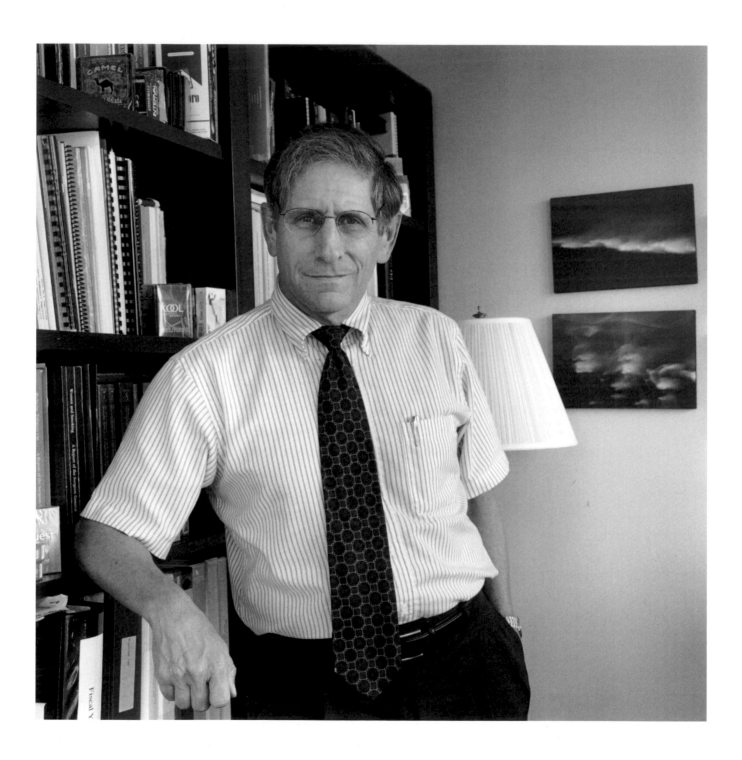

Matt Myers

MATT MYERS GREW UP IN HERKIMER, NEW YORK, AND RECEIVED HIS BA FROM TUFTS UNIVERSITY IN 1969, with a double major in history and political science. After law school, he worked as a civil rights attorney for the ACLU. In the fall of 1980, he joined the Federal Trade Commission to take over an ongoing investigation of the tobacco industry. In 1996, Myers helped to found the Campaign for Tobacco-Free Kids, of which he is president and CEO. He was also involved in the negotiations that led to the historic Master Settlement Agreement in 1998.

❧

I believe that if an alien from another planet — or historians, hopefully, a hundred years from now — were to look at the period from 1964 through to today, they would ask how a society knowing what we knew about what tobacco did — *does* — could do so little. No rational person could have calculated this. The leaders of our scientific and health communities in the 1960s had the incredibly mistaken belief that once the surgeon general had concluded unequivocally that smoking caused lung cancer and other diseases, society would respond. It's easy to look at the period 1964 to 1970 and ask, How could these major organizations, these major medical establishments, have done so little? What you realize is, it truly never dawned on them that with the strength of the science and the magnitude of the problem, that government institutions and society as a whole wouldn't respond. I don't think it dawned on them that there could be an industry run by people who would respond with such callousness and disregard. As a result, the public health response in that first period of time was so out of proportion — in terms of so little relative to the magnitude of the problem — that it's staggering. When you examine it, you recognize that it didn't dawn on them what kind of unscrupulous, amoral foe they were facing.

Since the 1950s we've gone through cycles. Every time the industry is under pressure, the industry makes grand pronouncements that they are fundamentally reformed. And the pronouncements amount to, "We're going to tell the public everything we know about this product. We're going to research and investigate it, because we care about the health of the American public as much as anybody else. And we think it's wrong to prey on kids — and we haven't, but you can be certain we won't in the future. And we'll go to great lengths not to do so; in fact, we'll even design public education campaigns to discourage kids from smoking." That all sounds wonderful until you realize it's a broken record. They said it in the 50s; they said it in the 60s; they said it in the 70s; they said it several times in the 80s; and they said it several times in the 90s. And if you actually track it, they just wait long enough for everyone to forget they said it before, and they say it a little bit differently each time, because society has changed. But some of the quotes are virtually the same quotes they've used before.

America's commitment to rugged individualism, which plays such an important role in our society's success in so many areas, has been used by the tobacco industry to stifle outrage and concern about tobacco use. Lung cancer victims shy away from talking about it because they feel guilty that they've brought it on themselves. But as David Kessler once said, "When you see somebody dying of lung cancer, you're seeing the last chapter in a book that almost always began when the person was a teenager."

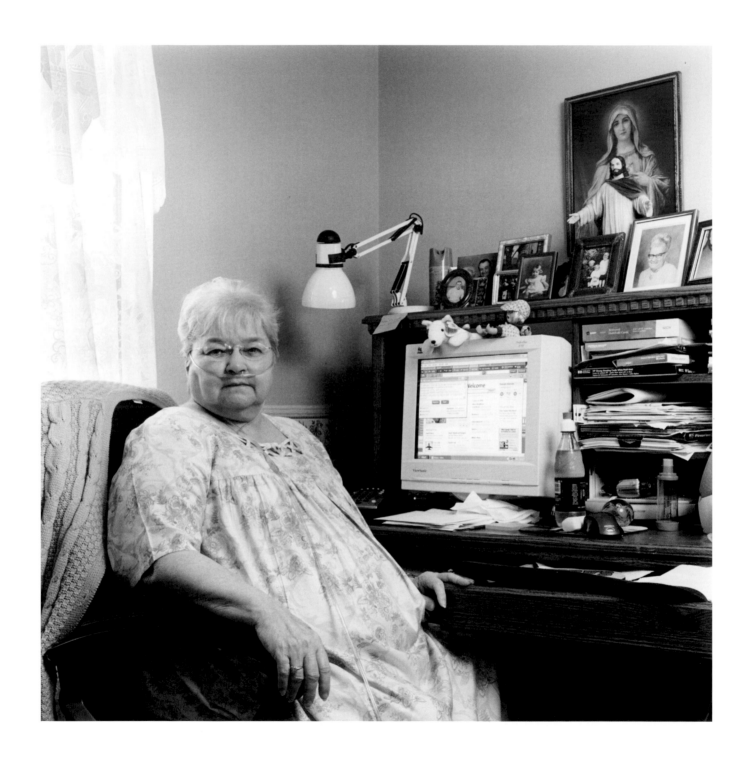

Maxine Click

KENTUCKY NATIVE MAXINE CLICK, BORN IN 1938, WAS THIRTEEN WHEN SHE STARTED SMOKING. She was a two-pack-a-day smoker before she quit in 1985 after developing shortness of breath. Because the lung damage caused by smoking is permanent, and because lung elasticity decreases with age, Click's lung capacity is now only 28% of normal, severely limiting her mobility and necessitating constant oxygen use. Click is the local coordinator of a national support organization for emphysema sufferers.

~∾~

My father smoked and I'm sure COPD [chronic obstructive pulmonary disease] is what he had, and it didn't stop me from smoking. Dad would start coughing and just about pass out. He really needed oxygen, but back then we didn't know about things like this. See, my dad died in 1967. I think it was from smoking. I really do. He had a heart attack when he died. He was 53.

I was smoking two, two-and-a-half packs a day. When I'd go to the mail box I'd wheeze and get short of breath. I thought it was my heart or my lungs, and I was just getting afraid of cigarettes. So I set me a date to quit. It was at the end of June, 1985. And I mean to tell you I smoked cigarettes that day! I got it into my head that I was gonna get full of 'em, and I did. When I went to bed that night I was just pure drunk on 'em. I remember when I put that last cigarette out, I said, "With God's help, I hope this is the last one I'll ever smoke." And you know what? It was. I've not tasted one since. It's been a rough way to go, but I done it. You've got to really want to quit. You ain't going to quit for nobody else. You got to want to do it for yourself. After I quit, I realized how much they ruled our life. Everything we done, we had to plan it around that cigarette. It's funny, because now it pure makes me sick to smell a woman with a lot of perfume and cigarette smoke together. At one time we did that, and we thought we was really something. We didn't know we was stinking like skunks.

The emphysema just really shuts your breath off. It's like taking a little tiny coffee straw and trying to get a deep breath through it. You just can't do it. That's what it feels like. You know, I love a pretty yard, and if I'd a stayed able, I would love to have kept doing that, working in the yard. I loved to go to church, and I can't go there no more. I really miss that. This is a disease that causes some people a lot of shame. It's like if people see you with oxygen and they know you got [emphysema] because of smoking, they feel like you got what you deserved. I think that's why you don't hear more about it.

The stairs are hard. I can't walk to do nothing. I don't get out much, especially in the winter months, because of these flus and all this. You know, it's not usually the COPD that kills you. We get the flu or get a cold and it goes into pneumonia, and then you're gone. But in the summer I can get out more. I've got a four-wheel scooter, and then I've also got the electric wheelchair. So like I said, I've been fortunate. More fortunate than a lot of others.

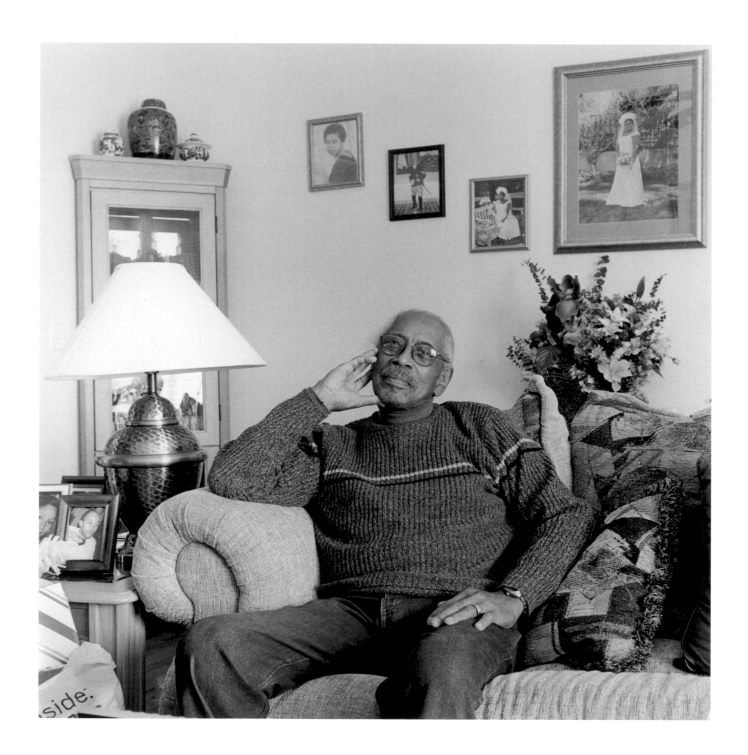

Don Cole

IN 1945, AT AGE FIFTEEN, DON COLE FORGED HIS MOTHER'S SIGNATURE SO HE COULD JOIN THE ARMY. He started smoking soon thereafter. He quit smoking in 1984, but kept working in smoky environments. In 1994, he had a cancerous right lung removed. Six months later, he received chemotherapy to knock out cancer cells that had spread to other parts of his body. Cole is statistically rare: the five-year survival rate for stage-four lung cancer is less than five percent.

❧ ❧

My father and my brothers, they all smoked. And they were always smoking. I didn't think anything of it. But that could have been the beginning of my desire to smoke cigarettes. When I went in the army, everyone else was smoking, so I started smoking. In the field they'd give you free cigarettes with your K-rations. You'd get four with every meal. That's when I started smoking. Well, I started smoking in the barracks, but those cigarettes in the K-rations helped me along the way.

The doctor told me that the percentage of people who recover from lung cancer is very low. I was thinking about this — the fact that my brothers and my dad all smoked in the house. Those three brothers and my dad all died from emphysema. All of them. My youngest brother, it was pretty sad. He wasn't a party-type person. He didn't go out a lot. He was a family man. But he used to smoke cigarette after cigarette. After I quit, I told him, "Man, why don't you throw them cigarettes away? They ain't no good." But he never stopped. And he died five years ago. My youngest brother.

When they told me that the cancer had metastasized, then I *knew* that was it. I felt that my life was over. But then I went through six cycles of chemotherapy. Two hours, once a week, for six cycles. *That* almost killed me. It took 72 pounds off me. I was like a walking ghost. It took about a year to get back to a little bit of normalcy, because for the first eight or nine months I could barely eat. Food smelled awful, it tasted awful, and I couldn't stand household odors — like soap, and stuff like that; it made me sick. It took months for my body to reacclimate to smells, and then I could eat again. But for the first six months, all I ate was Ramen noodles. The only thing I could digest was noodles.

I'm cancer-free now. I go to the VA for periodic checks. Every time I get a cough I rush to the VA, because it reminds me of what happened ten years ago. When I got the first diagnosis, I was devastated. I thought it was a death sentence, because I'd known so many people who'd had cancer — they'd go into the hospital for cancer and a few months later they were dead. So I cried, and I called to let people know that I had cancer. At that time I wasn't a very religious person. I mean, I *went* to church, but I didn't *know* about it. Until I got in the South here, then I became a little religious. I wouldn't say deeply religious. Not as deeply religious as I am now. Of course, now I wouldn't know what to do without praying to my Lord. I wouldn't know how to survive.

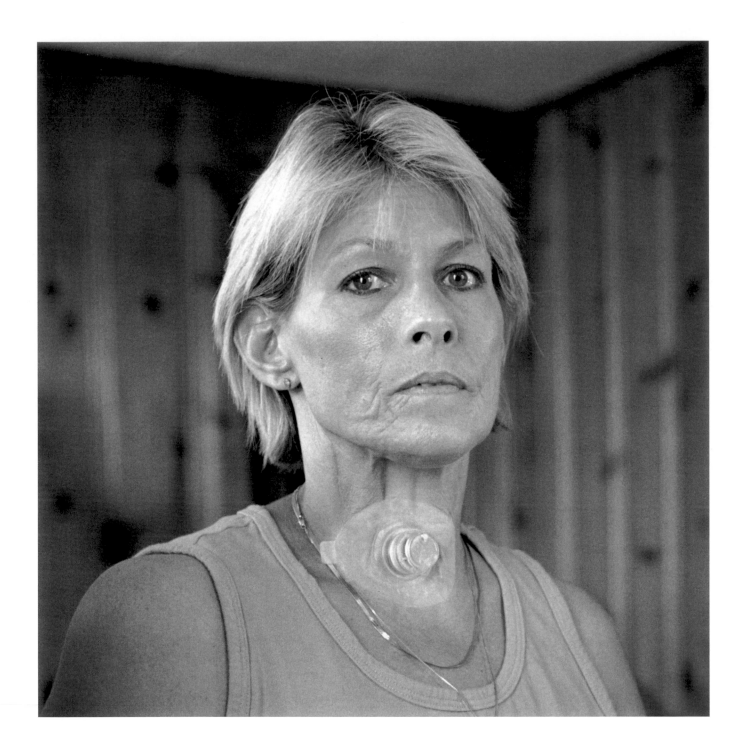

Terrie Hall

FOR NINE YEARS AFTER SHE GRADUATED FROM HIGH SCHOOL IN 1978, TERRIE HALL SMOKED "SOCIABLY," as she put it. "Only when I went out drinking or partying." Her consumption increased to two packs a day after a divorce that left her single with a young child. In 1999, she was diagnosed with mouth cancer, for which she received thirty-three radiation treatments. Two years later, she was diagnosed with throat cancer that required a laryngectomy. She did not quit smoking until after the surgery.

<center>∾ ⌒</center>

I was in shock when they told me they were going to take my voice box out. It didn't really hit me that I was not going to be able to talk until a woman who was a laryngectomee in my support group came and showed me the hole in her throat. When I saw the hole in that woman's throat, I thought, God, nobody is ever going to look at me again. I divorced from my second husband in 1998 and I haven't been on a date or been with anybody since, but I have not even been interested since my laryngectomy. I feel unattractive. I don't even know what it's like to kiss with a laryngectomy, with a stoma. So in that aspect my life has changed.

[After the surgery] when I was going through the depression, I didn't want to socialize. I didn't want anybody to come see me. I avoided people for months. Not only did it affect me because of how I had to communicate, but because of the way I looked. When I looked at myself the first time in a mirror at the hospital, I lost it. My neck looked about that wide and there was a real big indention. My chin looked like it was out to here and I just felt ugly. I felt mangled. And then when I heard the way they do the surgery — they pull all of your skin all the way above your face — that blew my mind.

A lot of people who have laryngectomies wear stoma covers. I go out with mine open. I wear tank tops, sleeveless tops. It doesn't bother me anymore because I've got to face facts. I'm going to be like this for the rest of my life, and I don't want to hide it. And the more people that see me and are aware of it, the more who are going to be aware of the facts. The first question they usually ask me is, Did you smoke? And I have to say yes, because it's the truth.

I've been through cancer. I've been through the loss of my mother. I lost a little girl that was three years old. God's got a reason for me somewhere for something, and I really feel like [doing anti-smoking workshops for school kids] is it. I really feel like he wants me to try to do something to help other people, and that must be my purpose, because there's got to be a reason I'm still here. I've been through cancer five times. So you make the best of it. I do that or I give up.

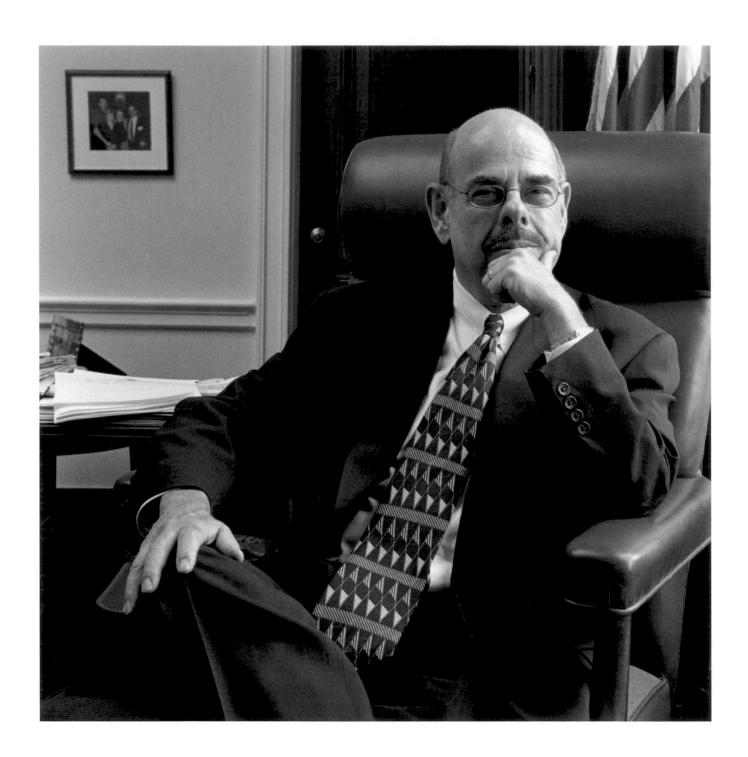

Henry Waxman

Democrat Henry waxman was elected to the u.s. house of representatives in 1974. During his tenure in Congress, Waxman has been a leader in fighting for tobacco control and other public health legislation. In 1994, Waxman convened and chaired the hearings during which the CEOs of the nation's seven largest tobacco companies infamously testified that nicotine is not addictive. He also led the effort to pass the Family Smoking Prevention and Tobacco Control Act in 2009.

❧

I decided early in my elected career to focus on health issues, and it's impossible to think about health issues without thinking about the impact of tobacco. Four hundred thousand people die each year in the United States. That's the mortality. Now add all the diseases that are related to tobacco and the costs of treatment, and the impact on society is enormous. So I've been focused on [the tobacco] issue from the very beginning, both in terms of what is the full impact of smoking, and then also how can we get people to stop, and how can we keep children from starting.

We had hearings [before 1994] where we tried to draw public attention to the harm of tobacco. Every time we had a hearing like that, the tobacco industry would ask to present a panel of witnesses, usually presumed scientists, who came in at the expense of the industry to say that there was no certainty about the connection between cigarette smoking and disease, that there was no *proof* of such a relationship. Later we found out that this was a strategy by the industry to keep doubt going so they could get smokers to continue to smoke. As early as the 1950s, as evidence was emerging about the harm from cigarette smoking, the industry promised the public that it was going to research the problem, find out the truth, and, if there was a problem, they would deal with it. In fact, what they did was to send out misleading information for decades to continue selling cigarettes to Americans.

In 1994, there was a buzz that nicotine was not simply an incidental by-product in what the tobacco industry was selling, but that they were able to manipulate nicotine levels. This was a dramatic revelation. So we asked the executives from the tobacco companies to testify before our committee on this and other issues. To my surprise, they all agreed to come. So we had all the chief executive officers at that famous 1994 hearing where they took an oath to tell the truth, and then proceeded to lie about the connection between cigarette smoking and disease; about whether nicotine was addictive; about whether they manipulated the nicotine; and about whether they targeted children in their efforts to attract new smokers. I think this had a dramatic impact on how the American people and others around the world viewed the tobacco industry. Here you had the men who were in charge of the industry willing to come before Congress and the public and say things that just weren't true.

I can't tell you how many times people have thanked me for pursuing this issue because they have had loved ones die from cigarette smoking. Oftentimes people will say to me, "I'm a Republican, but I want you to know how much I appreciate the fact that you went after the tobacco industry, because my mother, my wife, my husband died of cigarette smoking." That support has always given me a great sense of satisfaction.

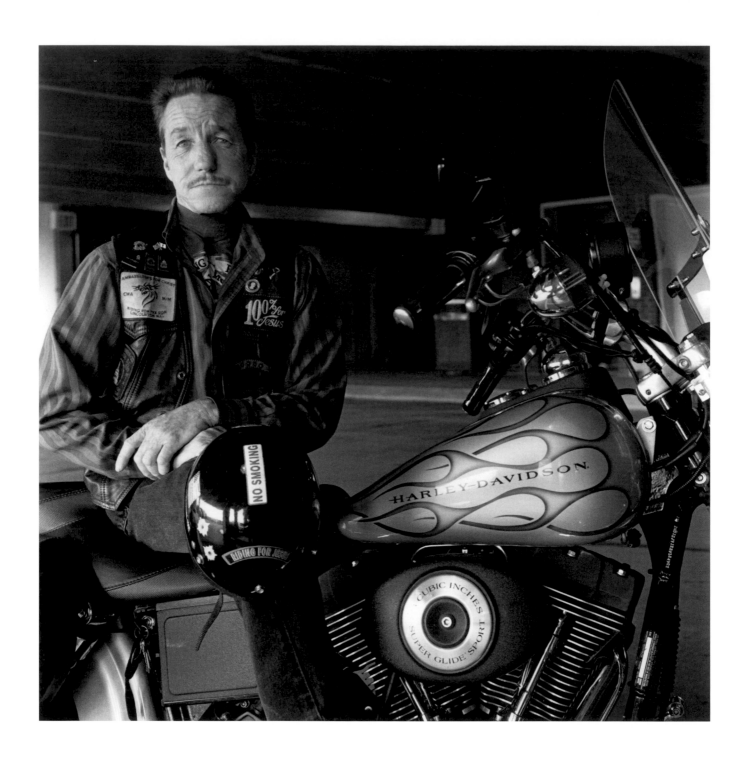

Fred Haywood

Fred Haywood was 36 when he was diagnosed with throat cancer in 1990. He'd started smoking late — at eighteen, while working construction. "It was a break-time thing," he said. "I smoked to go out and be one of the guys." Haywood had surgery to remove his larynx, and then thirty-five radiation treatments. After a year of being unable to speak, he had an operation to allow him to use a Blom-Singer voice prosthesis. Haywood now counsels cancer patients and does tobacco-control education in schools. He is also an avid Christian biker.

❧

About five nights after the surgery, I went to the nurse's station and asked for a cigarette. The nurse said, "Come here, honey. I want to show you something." She took me to a mirror. First time I'd seen myself after the surgery, and I looked bad. She said, "Are you *sure* you want a cigarette?" I had that craving like you couldn't believe. And I just kept nodding my head and saying, "Please, please, please." She said okay, and she went to her purse. And then she sat me down in the nurse's station, gave me the cigarette, and lit it. And then she said, "Go ahead, puff." And I didn't know you can't puff, 'cause you don't breathe through your mouth no more. You breathe through the stoma. So the stupid cigarette wouldn't light, and I started getting upset with her. And she says, "If you want that cigarette so bad, you've got to put it over there [over the stoma]." I just gave her back the cigarette. I was not about to stick a cigarette in my stoma. To smoke from there? I felt lucky to be alive. I wasn't even supposed to live. How stupid would I be to put a cigarette there?

When you get cancer, you want to blame somebody. But you can't blame them. As mad as I am at the tobacco people, I'm not mad at them because they sold cigarettes. It was still my choice to smoke. I'm mad at them because they didn't let us know how dangerous cigarettes are. Even after I talk to them, some kids will say, "I'm not worried," and they'll light up a cigarette. But I tell them, "When you get told you've got cancer, remember this day." Because there's nobody left to blame after you meet me but yourself. If you're not smart enough to put 'em down after you speak to one of us, one of the survivors, then who you gonna blame? When I grew up, we weren't told about the dangers. These kids today are told, and [when I go into the schools] they're *shown*.

ALAN
LANDERS

Height: 5' 11½" • Shoe: 9½ • Eyes: Brown • Hair: Brown
Jacket: 40R • Shirt: 15½/34S • Waist: 33 • Inseam: 32

**Winston tastes good
like a cigarette should.**
King Size and Super King Size.

Winston

LIFESTYLE

Model for
Cancer

Alan Landers

ALAN LANDERS (ALLAN LEVINE) WAS BORN IN 1940 AND BEGAN SMOKING WHEN HE WAS NINE. After a stint in the army, he became an actor and a model, appearing in ads for Winstons and Tiparillos in the 1960s and 1970s. In 1987, he had a malignant tumor removed from his right lung. Less than two years later, he had a second tumor removed from his left lung. In 1995, he sued the R. J. Reynolds tobacco company for marketing a defective product. When he did tobacco education in schools, Landers appeared as the "Winston Man." He died in 2009.

❧ ❧

The warnings are insufficient. The proper warnings are the ones in Canada: It *gives* you lung cancer. It *gives* you stroke, heart attack, emphysema. It *gives* it to you — no ifs, ands, or buts. I saw an ad yesterday in *Cosmo*. They took the whole centerfold of *Cosmo* for Camel cigarettes. And the [warning] was, "Caution: Contains Carbon Monoxide." Come on, give me a break! They're selling glamour and that whole thing. But they don't list the ingredients, the chemicals and carcinogens. So it's still the biggest con job of the century.

Smoking is the most selfish act in the world, because not only are you killing *yourself,* but in the process you completely destroy a family. Your loved ones suffer just as much; you leave children as orphans; and you destroy the whole family when you die from smoking. So there is nothing more selfish that a person can do [than] to smoke. Plus, secondhand smoke also is deadly. What about your loved one? You expose *them,* and they're not even smoking.

I would like to see the Food and Drug Administration get off their ass and regulate nicotine as the deadly drug it is. If they regulate it, they can lower the amount of nicotine that goes into the tobacco. And then if you're not going to get addicted to it, you're not going to smoke. There's no joy in smoking. It's disgusting. You stink. So regulate it as the deadly drug it is. Lower the amount of nicotine and gradually you're not going to have smokers, you're not going to have a market, and they're not going to manufacture it.

[Teenagers today] buy the same illusion that I bought, which is presented through the marketing of the product, that smoking is cool. That if you smoke, you'll be successful. You'll be hip. You'll be rocking. You'll be macho. You'll be sexy. You'll be accepted, wanted, and loved. When I do a presentation, I go through the whole list. And then I'll go, "Bang! Lies! All lies! Don't believe a word of it." I tell [teenagers] what a con job it is, what's in the product, the chemicals and carcinogens. You're making *them* rich and *you're* dying.

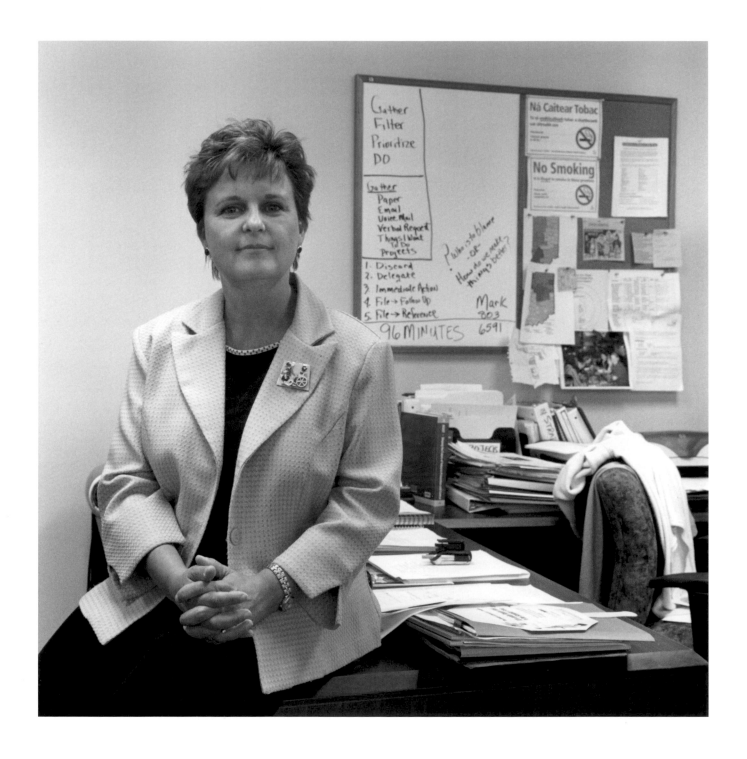

Karla Sneegas

KARLA SNEEGAS BECAME EXECUTIVE DIRECTOR OF INDIANA TOBACCO PREVENTION AND CESSATION IN 2001. She got into tobacco control in 1992, when she was hired to direct the National Cancer Institute's experimental ASSIST (American Stop Smoking Intervention Study for Cancer Prevention) program in South Carolina. Her grandfather died of lung cancer caused by smoking. When she was in fifth grade her father quit smoking. "The 1964 surgeon general's report was a big factor in convincing him," she said.

❧

Our money comes from the Master Settlement Agreement, but it comes through the legislature, so we're always vulnerable. There's one state senator who wants to completely do away with us. He has made comments like, "Over my dead body will you be funded." This [funding insecurity] is a reason why some people work in tobacco control for a while, then take a job where the funding is more stable. We probably lose a third of our local coordinators every year because of burnout and insecurity. But the good part is that the science and the evidence we rely on are incredibly strong, not just about what tobacco does to your health but about how to change behavior. Even so, we're always going to be the underdog, because we're outspent by the tobacco industry.

Raising the tobacco tax and passing smokefree air laws are two of the best prevention measures you can take. Yes, we need to educate. But education, in and of itself, without changing the environment, is just dropping pennies into the pond and it's not going to make much difference. The old model of badgering adults, using scare tactics, and the just-say-no kind of thing doesn't work. We know that it works if you raise the price enough, because that's the last straw for a lot of smokers. They'll say, "Okay, that's it. I'm done." *Then* you need to have the education program in place so that they can latch onto it and be successful in quitting. I think it's in these areas, in knowing what kinds of policies work, that the tobacco control movement has made great strides.

A lot of people don't understand the relationship between economic development and tobacco control. We've been working hard on this — to help people understand that if their communities have a high smoking rate, then they're at a competitive disadvantage for getting business. One of the best things that's happened in Indiana is that the [2006] chair of our Economic Development Corporation, which is the old Department of Commerce, is an advocate for tobacco control. Every place he goes, he talks about that. He says, "We've got to lower our smoking rate, because I can't get companies to come here if we're not healthy. If you pass a smokefree air ordinance, that's going to make your workforce healthier and more companies will look favorably on your community."

What have I learned about tobacco companies? Number one, never trust them. Never, ever, ever, ever trust them. Just because they're saying one thing doesn't mean that's what they're doing. They may be doing something different here in the U.S., but they're certainly not doing anything different in Africa or China or South America. We need to continually bring to light what the industry is doing and continues to do. Our failure to do that is harmful for the entire world.

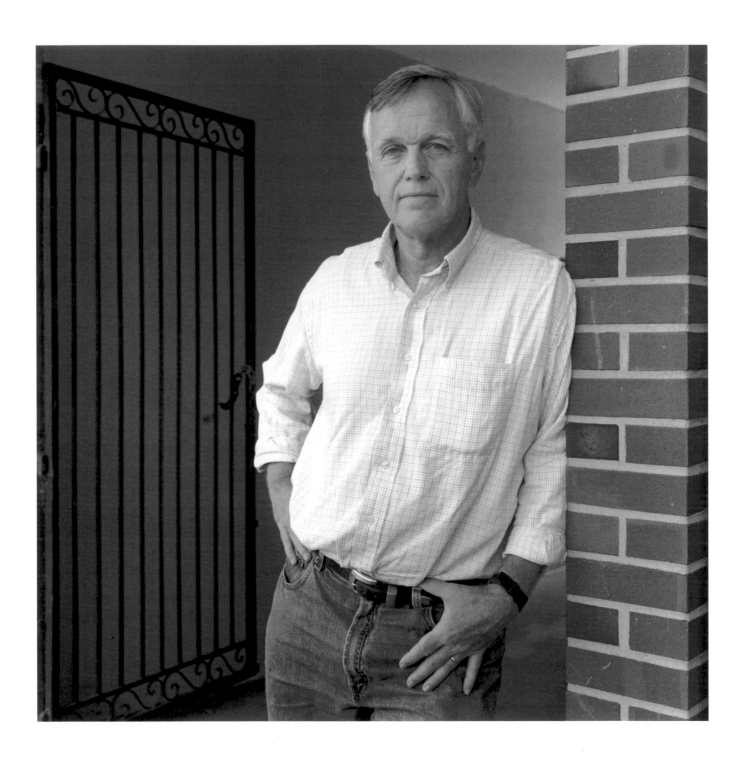

Clyde Edgerton

NOVELIST CLYDE EDGERTON GREW UP STEEPED IN NORTH CAROLINA'S TOBACCO CULTURE. His grandparents were tobacco farmers, and his father carried on the tradition until he left farming to sell insurance. Edgerton's father was also a smoker who died of heart failure after suffering from emphysema for many years. Among Edgerton's best-known novels are *Raney, The Floatplane Notebooks, Walking Across Egypt, Where Trouble Sleeps, Killer Diller,* and *The Bible Salesman.* He teaches creative writing at UNC–Wilmington.

~ ~

My father started smoking when he was twelve. At the time, there was no pronouncement that it was bad for your health. He quit at 62 because his breath was getting short. He brought me to baseball and to quail hunting. Those were what he passed on to me in a symbolic and real way, and I lost him to quail hunting after a while because he couldn't walk. We could *talk* baseball together, but we couldn't go hunting, as a consequence of tobacco. He was finally unable to walk to the mailbox. He died at 77 of an enlarged heart — a consequence of emphysema. So I watched fifteen years of deterioration and suffering.

This whole thing — tobacco — was such a *norm,* and it's difficult to critique a norm. It was all around us, and so you don't see it, like a fish in water. The fact of what corporations were doing to people's health, for money — people couldn't see it, because it was so big. If the tobacco industry were a *person* walking house to house and you could see the destruction left behind in every house, then that person would be strung up. But tobacco was so big that to be angry at tobacco — it's almost like trying to be angry at the sky. The sky is there. What difference would it make if you're angry at the sky? But if you're forced to think about tobacco, you realize the robbery.

It's an age-old problem of power versus well-being. I once heard an economist say, "From an economic point of view, small farms are not viable." And I thought, During the time of slavery someone could have said that, from an economic point of view, we must not abolish slavery. I think this shows what can happen when you allow morality and ethics to get out of your thinking. So I think we need somehow to find a way through government to examine our norms and examine what we believe is acceptable as it relates to health and, in the case of tobacco, pass laws that prohibit the killing of people. I don't see any answer beyond enforcing health standards that prohibit any big business from doing harm to people.

[When I was on the Council of Churches tobacco panel in 1984], we had a lot of people come in and say, "If it weren't for tobacco, your churches wouldn't thrive like they do. If it weren't for tobacco, your schools wouldn't thrive like they do." That connection isn't necessarily false, but it's the same one that was made with slavery. If we look back at that, at slavery, we would knock down this argument. But we won't do it when people talk about tobacco and what it's doing for our economy. We won't look at a damn thing if it's doing something for our economy. I can't help but believe that if *flooding* "did something for the economy," some people would want to go out and cause floods.

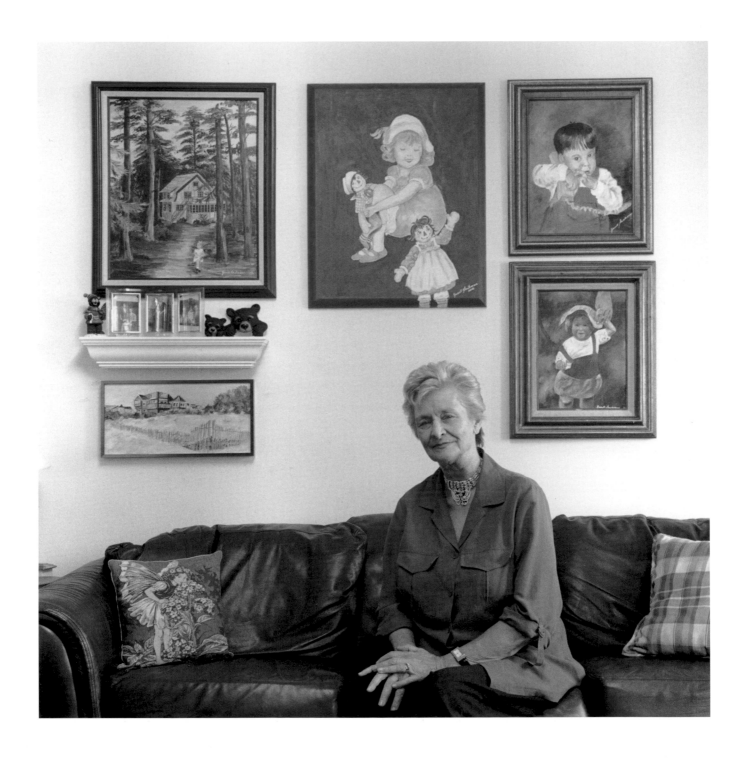

Janet Sackman

WHEN JANET SACKMAN WAS SEVENTEEN, SHE APPEARED IN CHESTERFIELD ADS ON PERRY COMO'S TV SHOW "Chesterfield Supper Club." When she later modeled for Lucky Strike, a tobacco executive suggested that she learn to smoke. She did, eventually consuming more than a pack a day. She quit smoking in 1983 after being diagnosed with laryngeal cancer (she survived lung cancer in 1990). Despite the removal of her vocal cords, Sackman has traveled the world to speak as an anti-smoking activist.

❧

My throat cancer was in 1983, so I'm living overtime. I would have never believed it. They weren't confident, so I thought I was going to die. I went through very strong radiation therapy. I was allergic to that. I swelled up and couldn't even move my head. So they lowered the dose and I got forty-five treatments instead of thirty-five. That left me with strange, tingly pains for years. I think the radiation affected my nerves. Then there was a period where I thought I was fine. Not right away after the surgery, but within maybe two years I felt fine. Then some years later I went for my regular check-up and — thank God that Sloan Kettering is very conscientious; they really watch. They sent me for an X-ray and found a tumor in my right lung. So they took a third of the lung out. I was pretty sick after that. That knocked me for a loop, because I didn't expect anything. It was not the same cancer as the throat, but both were from cigarettes.

When the information about cigarettes first came out, I couldn't stop. I couldn't. I said I would every day, but I just couldn't. And, you know, nothing could happen to me — that's how I thought. It's everybody else but not me. That's how a lot of kids think: "not me." Kids are getting bad again. For a while they were good. But now they're back to puffing away. I go over to them — and one of these days I'm going to get punched in the face — but I just feel I have to. And sometimes they're very nice, and sometimes they're very nasty. I saw a young girl puffing away, high heels on, all made up, sitting on a stoop. I went over and lifted up the patch [that covers my stoma] and said, "Do you want this? Because this is what smoking will get you." She said, "Yeah, yeah, tell me all about it," and got up and left.

I wouldn't want anybody to go through what I went through. [A laryngectomy] is a very difficult operation to get used to because of [the hole in] your neck. It's also very hard to not be able to talk and express yourself. People look at you like your brain isn't working anymore. That's very demeaning. A lot of people when they have their voice box removed don't go out anymore. They make themselves hermits. Another thing is, doctors operate and they don't tell you what to expect, although you learn quickly when you find out you can't talk. This is why we have support groups. I've belonged to a speech club for over twenty years. But the members are dying off. Sometimes throat cancer comes back. Most of the time it's lung cancer. I don't know why. People don't want to think that that could happen to them. They're in denial, I guess. I didn't think about it, either. I'm very fortunate that they caught the lung cancer. I hope and pray I get another ten or fifteen years.

Cliff Douglas

IN 1988, WHEN HE WAS STILL IN HIS TWENTIES, CLIFF DOUGLAS WAS THE ONLY LAWYER WORKING FULL-TIME IN tobacco control in the United States. Later he worked as special counsel on tobacco issues for congressman Marty Meehan (Dem.-Mass.), who spurred the Department of Justice to launch its historic case against the tobacco industry. Douglas has also been a consultant in many of the major tobacco liability lawsuits over the last two decades. His father, an oral surgeon who also served in the Illinois state legislature in the early 1970s, introduced the state's first smokefree air law.

The way that modern society has politically and culturally protected this extremely harmful, death-dealing institution has as its equivalent the way society protected the morally repugnant practice of slavery. Some day people are going to look back and see lung cancer as a tragic historical anomaly of the 20th century, because when we get smoking behind us, it's going to largely disappear. The tobacco industry is a peculiar institution, unique really, not only because of the scale of its harm but also because of the snow job it's done on the public to normalize tobacco-related death and disease. At the most fundamental level, it's been a case of mass brainwashing.

I've tried to help people shift the burden of guilt and responsibility, at least in part, off their own shoulders and onto the tobacco industry, which is where I argue that it belongs. Sure, we have free choice and we make decisions as adults. But when I talk to lung cancer survivors I say, "The 'choice' you made that led to this disease, you made as a kid, years before you were mature and knowledgeable enough to understand what you were doing to your body." In simple terms the message is, "It isn't your fault. You were targeted by a multibillion-dollar industry that was far more powerful than you and was doing things, and doing things to you, that you knew nothing about. Not only were they enticing you as a kid into smoking cigarettes, but they were manipulating those cigarettes to ensure that you would become addicted and stay addicted."

Litigation has been valuable in educating the public, because without litigation we wouldn't have millions of pages of internal tobacco company memos and scientific reports in the public domain. Without all that, the whole legal landscape would look different. Litigation has also played a key role in bringing out whistleblowers who have helped shed light on how the public was duped over many years and how kids continue to be targeted today. Their testimony has brought us to a new level of understanding, and perhaps even turned what had been an evolution into a revolution, if that's not too strong a way of putting it — a revolution against the tobacco industry and in favor of taking sensible policy steps to regulate tobacco and get rid of smoking in public places where exposure harms other people.

Tobacco companies are going to be in business for the foreseeable future. The companies are smart enough that they've already positioned themselves to ride the changes into a different sort of tobacco industry, one in which they'll still be selling a huge amount of product, but a product that's been changed to satisfy modern demands for safety. Several of the companies have already started in unregulated ways to market these products, with pretty explicit health messages. We need regulation to determine whether these claims can be justified or not. But that's where we're headed, not to the absence of tobacco in this society.

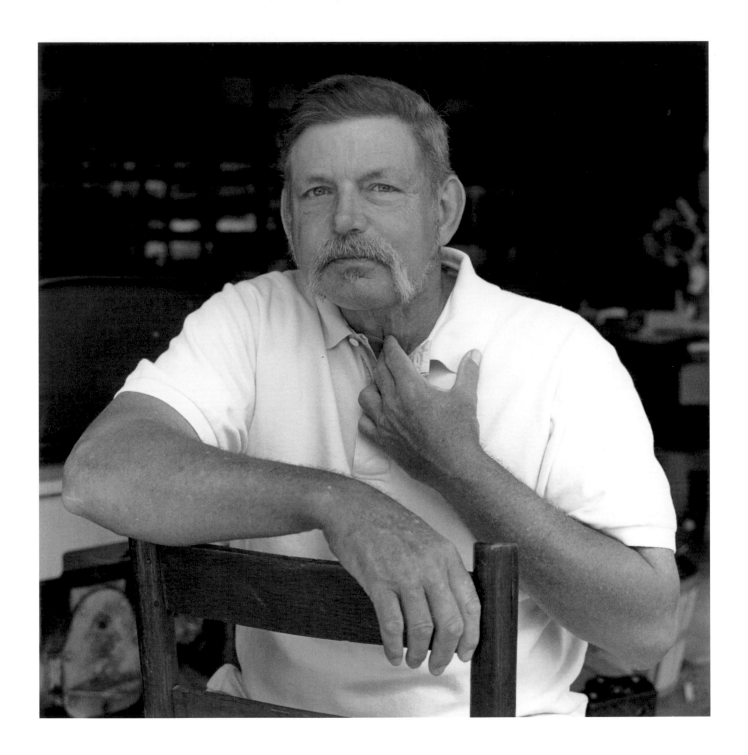

Wade Hampton

WADE HAMPTON WAS BORN IN 1947 TO A NORTH CAROLINA FAMILY THAT GREW TOBACCO, COTTON, CORN, and soybeans. At sixteen he began smoking — what he called "a standard rite of passage from male adolescence into adulthood." In 1994, he developed a persistent sore throat, which he treated by taking aspirin and gargling with salt water and Listerine. The eventual diagnosis was cancer of the larynx. After recovering from his laryngectomy and learning to speak again, Hampton began giving talks in middle schools to try to deter kids from using tobacco.

 ❧

When I first tried tobacco, it gave me a sore throat, it made me dizzy. I didn't like it. But I persisted because I wanted to be in that group, to be known as a smoker. There was no discouragement in that era. If a male smoked, it was okay. If a girl smoked, it was trashy. But nobody knew specifically that it was causing cancer. It was just an accepted thing. To be a man was to smoke.

At that time I didn't know about nicotine or the addictiveness of it. So once I got by a sore throat and the smell and the dizzy-headedness, I thought I was home free. From that point on, except for a couple times when I tried to stop, when I was doing certain things with athletics and it was affecting my breath and the length of time that I could sustain effort, I became and always was a totally committed smoker. I thought it was great. I thought everything in my life revolved around it. To eat and to smoke a cigarette was better than dessert.

About three months after my surgery I bought myself a pack of Marlboro Lights. I puffed on about six of them. I just puffed on 'em with my lips, and I got no satisfaction out of it. And there came a realization, like somebody tapping you on the shoulder saying, "This is *stupid*. You're playing Russian roulette and you're putting bullets back in the gun. You just had throat cancer. Don't be a fool. And don't be around smoke if you can avoid it." You know, it almost had gotten me. I was scared, too. So, finally, it just popped in my head: Give it up. No more.

When I started smoking, I thought I was bullet proof. What I found out is that I was vulnerable, that life is a fragile thing. I think it's a gift of God. We're blessed to have it. We normally live the majority of it not appreciating it. And [cancer] was my wake-up call to try to put a little more back in it than I was always trying to take out of it for me. Part of the reason I became addicted to nicotine is that there was a part of me that was very selfish. As long as smoking was good for me, the heck with anybody else. I didn't see anything wrong with it. I didn't think it was bad. I never thought it would touch me. I didn't realize John Wayne died from it. I didn't realize Babe Ruth and dozens more prominent people died from it. Nobody puts out a coroner's report that says, "Hey, it was cigarettes that put John Wayne in his grave."

Melissa Warren

MELISSA WARREN'S 58-YEAR-OLD FATHER HAD BEEN FEELING OUT OF SORTS FOR MONTHS and was having trouble keeping food down. His doctors at first diagnosed a kidney infection and prescribed antibiotics. After he insisted on more tests, the doctors discovered stage-three esophageal cancer that was deemed inoperable. The day before he was scheduled to begin radiation treatment, he developed pneumonia and died two weeks later.

❧ ❧

I'm hard-pressed to remember my father without a cigarette in his hand. He smoked all the time I was growing up. Even when we were in the car, he smoked. It wasn't as big a deal back then. People didn't think about secondhand smoke and what they were doing to their children. I can also never remember a time when he wasn't coughing. That's what I associate with my dad — he's sitting in his recliner with a cigarette, coughing. When I was in the fourth grade they had some kind of educational program on smoking and they brought in a cow's lung to show us what smoking did. It was really disgusting and I knew I didn't want to do it. But my dad — well, I was just a kid, and I couldn't tell my dad, "You can't smoke."

He quit one time when he had a heart attack scare. The doctor put him on a strict diet and said, "You have to quit smoking." And he did. He quit cold turkey, and I remember he was a total jerk for two weeks. Nobody wanted anything to do with him. For maybe four or five years, he didn't smoke. Then when he and my mother started having some marital issues, I noticed he volunteered to go to the grocery store a lot, or to do this or that errand. When he would come back, I could smell mouthwash on his breath, so I knew what he was doing. Finally, we all said, "Dad, we know you're smoking." After that, he didn't bother to hide it.

According to his girlfriend — see, my dad had moved away and we didn't talk that much — he hadn't really been himself for like nine or ten months. In the month before he went to the hospital, he couldn't keep any food on his stomach. And so she kept saying, "You need to go to the doctor." But my dad was stubborn and that's the last thing he would do, and it makes me angry that he waited so long. I read somewhere that people who smoke and have lung cancer often have no symptoms, so that once they find the cancer it's too late. But, I mean, if my husband was not able to eat for two weeks, let alone a month, I'd put him in the car and drag him to the doctor. So my dad's case bothered me. I just feel like maybe he could have been saved, if he had acted sooner.

He knew it was the cigarettes. And I think that made him feel worse — knowing he did it to himself, even though he'd been told to quit for years. I remember going outside with him when he was in the hospital. He walked to the picnic table, dragging his IV bag. He lit a cigarette as soon as we sat down. I didn't say anything to him; at that point there was nothing we could do. When I left, we hugged. That was the first and last time he ever told me that he loved me.

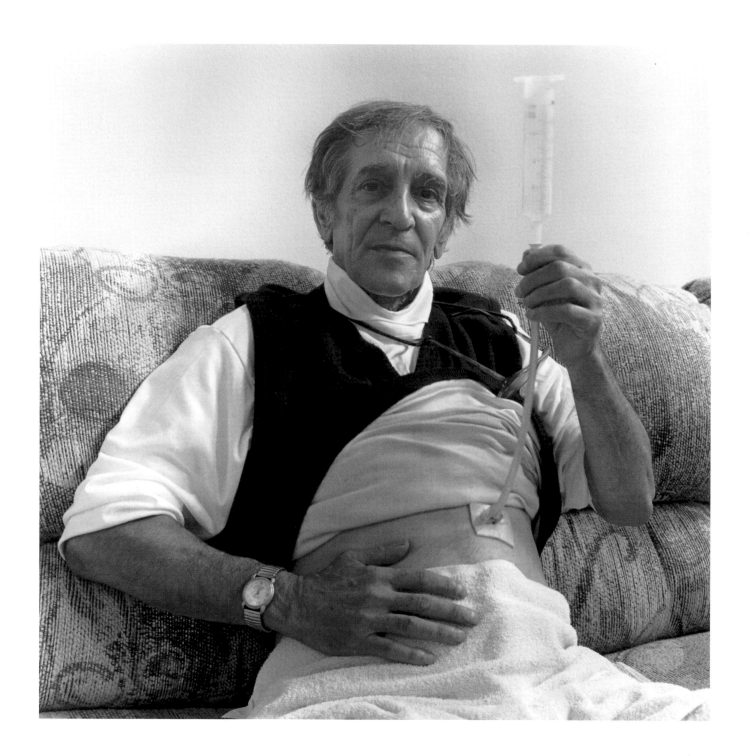

Frank Amodeo

FRANK AMODEO STARTED SMOKING IN 1953 AT AGE THIRTEEN. On his 48th birthday, he began spitting up blood when a bite of cake caused a cancerous tumor in his throat to hemorrhage. Seventy radiation treatments knocked out the tumor, but the tumor had destroyed Amodeo's epiglottis, leaving him unable to eat or drink through his mouth. Amodeo was one of the three representative plaintiffs in the *Engle* case and was initially awarded $5.8 million in damages, though the award was later overturned by the Florida Supreme Court.

❧

Three days from today [9 June 2005], it'll be eighteen years since the last time I swallowed any food, or had anything to drink. That's why my voice is so bad. My vocal cords are dry. I haven't had a sip of water in eighteen years. I can't explain how thirsty I am. Every day of my life I'm thirsty. If I swallow water, it goes into my lungs. So I can't swallow water. If I swallow anything, it goes into my lungs. If I ate food, it stops right here, and I'll choke. So everything I eat goes through this tube into my stomach, ten times a day.

All my idols smoked. Sammy Davis Jr., Dean Martin, Frank Sinatra, Mickey Mantle, Roger Maris. I wanted to be like these guys. Elvis Presley smoked. And I thought, Would these men smoke if they knew it was harming them? Arthur Godfrey, he used to be on radio. He had his ukulele and his Hawaiian shirts. He would say that Chesterfields are safe, scientifically proven safe! Although I never smoked his *brand*, not more than a pack or so, I thought a cigarette was a cigarette was a cigarette.

Maybe I'm naive, but I didn't believe the United States government would allow a product like this to be sold and be legal, if they knew it was going to kill you. I also didn't believe a big gigantic company like Philip Morris would sell 'em if they knew they were going to kill you. If I had a company and I knew my product was going to kill people, I wouldn't sell it. So at first I was on the side of tobacco. I really didn't believe they knew for sure. Waxman had these hearings in Washington and I saw all the CEOs get up in front of Congress and say, "I don't believe nicotine is addictive." And I told Margaret, "See? See? They feel the way I feel." I didn't believe they would lie under oath to the Congress of the United States. But then all these documents started coming out. And I said, "I was stupid." It was tobacco [that had made me sick], beyond a doubt. I had bought their story. I admit it, and I feel bad about it. But I bought into their lies.

When they announced the verdict and the judge said, "Boy, that's a lot of zeroes," I was ecstatic. I felt that, no matter what happens, we had won. A jury had heard this evidence in the longest civil trial in history and had just awarded us the largest punitive damages in history against these tobacco companies for their lies and deceits and for saying, for all those years, "There's no proof smoking causes a cough." People like me bought into it, choosing to believe them. So then I wanted them out of business. Let cigarettes go underground, black market. That would drop the percentage of smokers way down, probably down to ten percent. I think the only reason cigarettes are still legal is because the tobacco companies have a lot of people in their pockets.

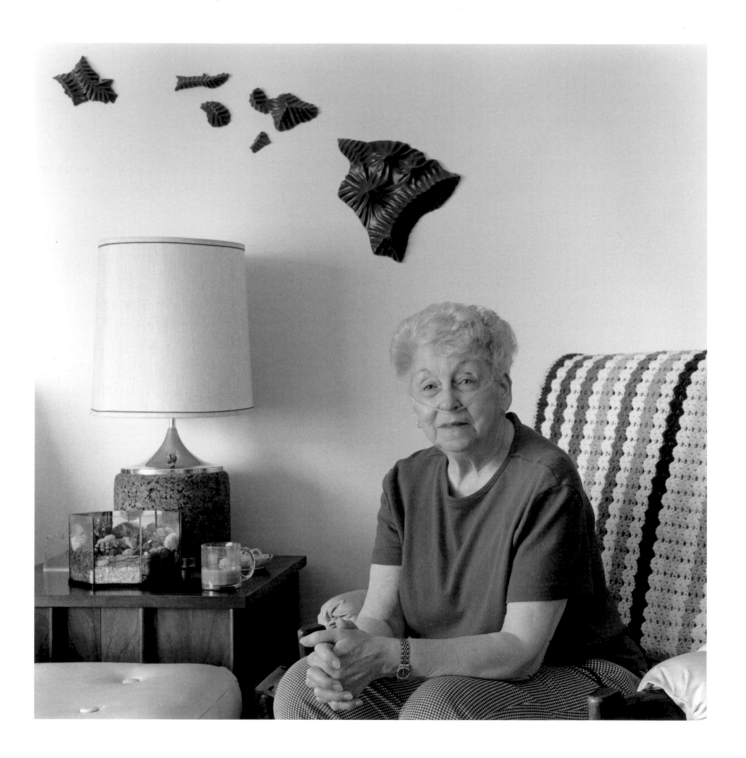

Betty Emerick

IN THE EARLY 1990S, BETTY EMERICK COULD TELL THERE WAS SOMETHING WRONG when she "couldn't push the vacuum cleaner and breathe right." She had been smoking for forty years. She attributed her breathing problems to asthma, but X-rays revealed advanced emphysema. Even though she quit smoking in 1997, Emerick's lung capacity continued to decline. By 2002, she needed to be on oxygen continuously. Her parents were tobacco farmers in Connecticut.

I started at sixteen and smoked for 47 years. In the beginning, about a pack a day. Then I went to a pack and a half and pretty much stayed at that level. I was hooked pretty quickly after I started, but I didn't *feel* like I was hooked, because it wasn't like I wanted to get off of it. I liked the feeling that I got from it. It did something for me. Sometimes it perked you up. It just sort of gave you a good feeling. If you were worried, it helped you not to worry. If you were excited, it helped you with that. It's just hard to explain.

There were earlier times that I tried to quit, and I never made it through a full day. I just could not do it. I could do it for a number of hours. And that's where so many of us make a mistake. So what if you have one? Try again and go on from there. But usually what people do is think, "Well, I can't quit," and then keep on smoking. Then you might try it again sometime and the same thing happens. What you have to say instead is, "Well, now, if I went *eight* hours, maybe I could go *ten* hours the next time." That's how you have to do it.

In the late 1980s, I started getting a cough, but that didn't bother me too much. I thought maybe it was bronchitis. I wasn't wanting to relate it to my cigarettes. But I could tell that there was something going on in me. Things were getting harder for me to do. I couldn't push the vacuum cleaner and breathe right. I could tell that I wasn't at my full capacity, and I was thinking, "This has to be my smoking. What's going on in there? Am I getting lung cancer?" It's scary to think about that. A couple years later a doctor took an X-ray and said, "I think you might have COPD." He told me that if I wanted to live, I had to quit smoking. But right then I couldn't.

I'm not blaming the tobacco companies. I mean, I do think they lured people into it and they knew what was happening. And what irritates me today is that we'll be watching TV and one of the tobacco companies comes on and they'll say, "If you need to quit smoking blah blah blah, or children need to quit smoking blah blah blah. Go to our website for tips." But they're marketing it to the kids. I mean, that's pretty evident to me. But they're going to help you quit smoking? Give me a break! And then in North Carolina, we know what tobacco does, and yet the farmers want to keep growing it. They say they need to grow it to live. And we say we need to have them grow it because we need them to keep busy. Why can't they get some other crops? I don't know. I don't understand the whole thing.

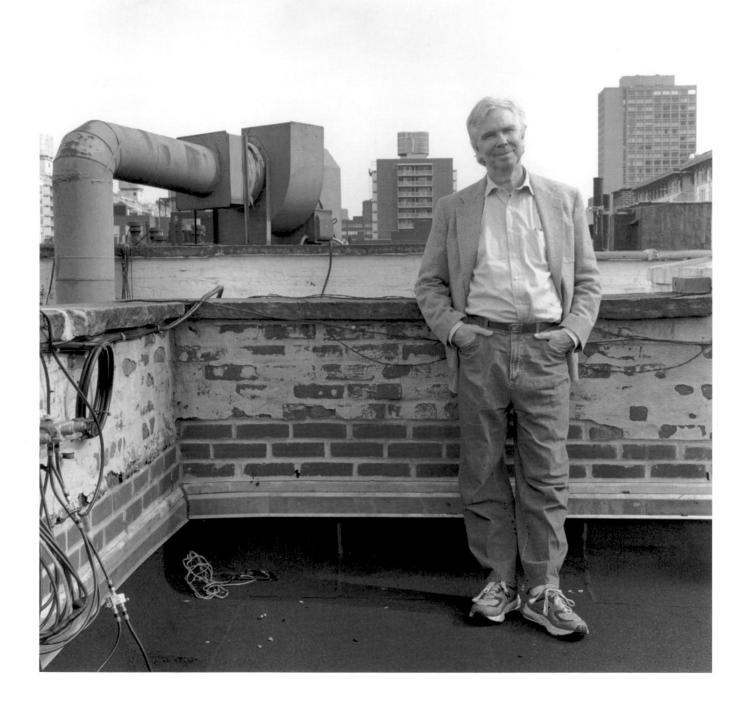

Gene Borio

SINCE 1998 GENE BORIO HAS DEVOTED MUCH OF HIS WAKING LIFE TO OPERATING *Tobacco.org*, the largest online source of news and commentary about tobacco. Borio posts 50 to 150 news stories per day on the site, all of which are archived in a searchable database. Borio has also compiled a timeline that tracks the history of tobacco from 6000 BCE to the present. An ex-smoker, Borio made nine serious attempts to quit before succeeding in the mid-1980s.

 ❧

[Back in the 1980s] I was waiting on tables with a friend who had decided to quit smoking. I remember coming in one day and she was going crazy — her eyes were watering and she was having a terrible time. I saw her and said to myself, "If that's not addiction, I don't know what is." I mean, I'd used drugs, and I thought, The tobacco companies must know that their stuff is seriously addicting. I started looking into the issue and I noticed that there was very little about it in the overground press. All that the magazines told you [about cigarettes] was what the ads told you. There was very little in the newspapers. I just thought, What's going on here? This thing is killing hundreds of thousands of people a *year*, and nobody wants to talk about it? It looked like a great big fat conspiracy. That's when I started getting involved in it and looking into things.

The media had ignored it for so long. There was also something about its arcaneness at that time that was fascinating to me. Like it was secret, underground knowledge. It was like nobody even considered it an issue at all. When I'd tell people that I tracked news about tobacco, I might as well have told them I painted my toenails in pink polka dots or something. It was like, You do *what*? Why?

Even in the early 1990s, the level of ignorance was deep, because there was so little coverage. So I started rounding up whatever [tobacco] news I could find. I would post a weekly summary of ten or twelve stories on one of the bulletin boards. In 1993, I got my own bulletin board system. My goal was to tell people that this is really a problem. We have a tremendously addicting drug that's causing hundreds of thousands of deaths a year, and, in trying to control it, we have a completely recalcitrant industry. That's a big, nearly intractable problem. And yet, if we're going to solve it, we have to know something about it. So that's why I was trying to spread the word. Something needed to be done, and I was in a position to do it.

I wanted to reach activists and the general public. I had the idea that once you see the information, you almost can't help but act. There were other sources out there but I wanted to bring it all together, provide information from all sources, including the industry. Then you could make your own decision about tobacco, though I didn't think it would be a particularly hard decision to make.

One of the letters I got that really pleased me was from a guy who said, "You've succeeded in doing what my mother couldn't do, what my friends haven't been able to do, what nobody's been able to do. I've read the stuff on your site, and I've had it! I'm quitting smoking right now!" A month later he said that he'd been able to quit smoking once he understood what was really going on.

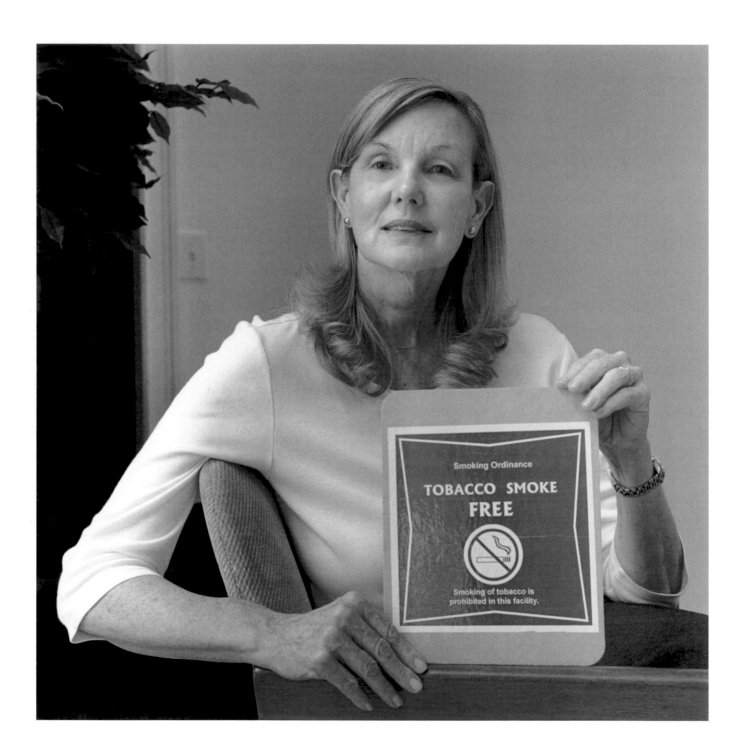

Kathie Cheney

AFTER GRADUATING FROM THE UNIVERSITY OF FLORIDA IN 1968, KATHIE CHENEY went to work as a flight attendant for Eastern Airlines. Though Cheney never smoked, she was diagnosed in 1987 with throat cancer, caused by exposure to secondhand smoke in aircraft cabins. Surgery and radiation knocked out the cancer. But the radiation — five days a week for three months — left her chronically fatigued. She never returned to work. "I have about two hours of energy each day," Cheney said. "I have to fit everything into that wedge of time. It's like I got old overnight."

～ ～

In a bar or restaurant, you expect the glass they give you to be clean, to not have bacteria on it. Now, it's cheaper to just rinse the glass in cold water and hand it to the next person. That will get rid of the smell of scotch. But, by law, they're not allowed to ignore the bacteria on their glass, because it spreads disease. Well, by law, they shouldn't be allowed to ignore the smoke in the air, because *it* causes disease. It's not that much of a stretch.

If drunk drivers didn't kill other people, if they only killed themselves, we probably wouldn't have such stringent laws. But they don't; they kill innocent bystanders, and that's why you don't drive home drunk. When I was growing up, people used to say, "That accident wasn't his fault. He was drunk." Well, we don't say that anymore. We don't excuse drunk drivers, and we shouldn't be excusing smokers, because now we know that they hurt other people, and *that's* where the laws are justified in changing. But to get laws to change is difficult.

In order to survive in a capitalist society, business has to make profits, and the tobacco industry is out there protecting its profits at any cost. Their concern — and it's just like the bar owners — their concern is not people's health. It's why we have to have regulations. We use the government to draw the line. We say, "Above that line, you can cut all the corners you want. But below that line, you can't go there." We have lots of rules and regulations that we didn't have before, but now we know we need to. Government draws the line and says, "This is where you can't go, even though it's profitable." Without government, we'd still have eight-year-old kids working in sweatshops, because it's profitable.

When I testified before the Atlanta City Council, I went up and said, "You know, I've had throat cancer and now I have a clogged artery. This is what tobacco smoke does to people. This is what it does to non-smokers. This is why you *need* to make this legislation. If you want to smoke, that's fine; hurt yourself. Don't do it to the non-smokers."

People don't put sitting in a smoke-filled restaurant or bar [together] with the heart attack or stroke they have the next day. We don't connect them, but we need to. That's how we'll prevent it. Seven years ago, people thought I was a kook for raising this issue. And when we finally got the smoke out, I'd be in the grocery store and a total stranger would come up to me and say, "You're Kathie Cheney. You're the one that got rid of the smoke. Thank you."

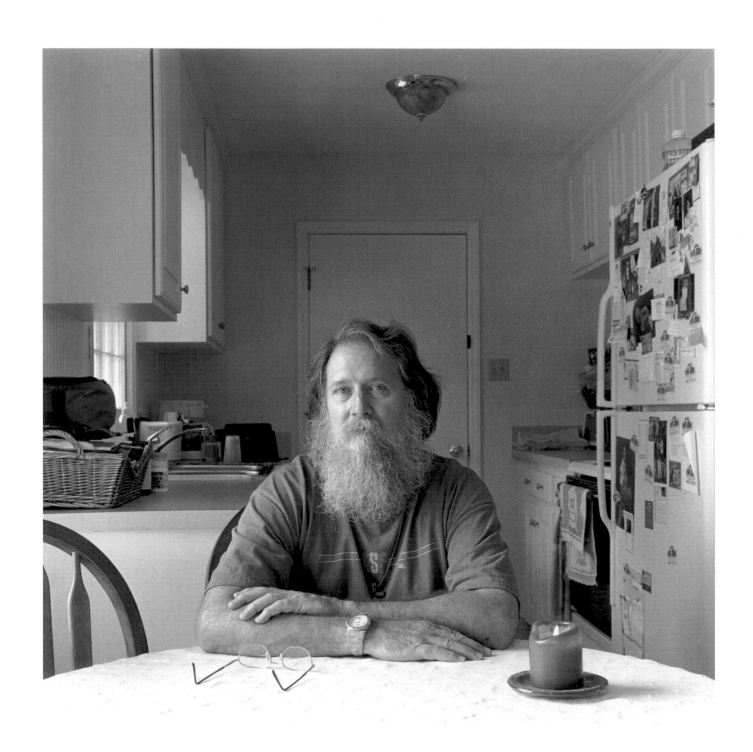

Shannon Suttle

SHANNON SUTTLE'S PARENTS WERE CHAIN SMOKERS. His mother died of breast cancer at 54. His father died of a pulmonary embolism at 56. Suttle blamed his parents' early deaths on smoking, though medical research at the time offered little supporting evidence. In the last twenty years, smoking has been identified as a risk factor for both breast cancer and pulmonary embolisms.

❧ ❧

My mother was a nurse for a long time, an RN. After she hurt her hand in a car accident, she couldn't give a hypodermic, so she sold Avon for a while and then retired. She died in 1982 at 54. The cancer went from her breast into her lymphatic system. My father was 56 when he died. He was a chain smoker and had a pulmonary embolism. He was dead before he hit the floor. I never saw him without a cigarette in his hand. That, and a beer. All that contributed to his deterioration, because there was no other reason for him to have died at 56. He wasn't overweight and had no prior history of heart trouble. Everybody in our family starts off healthy as a horse.

I smoked a pipe for a couple years, sometime around 1987. Every time I lit up my wife pointed out that my parents had died from smoking, so I finally stopped. But I still have a tremendous urge to smoke a pipe. It's funny, because my wife's father smokes a pipe and I can't stand it. Even when I was smoking a pipe, I didn't like it. But it made me feel calm. I don't know why, but it did. Maybe because it gave me something to hold in my hands, or because of oral gratification. I'm a recovering alcoholic. I have ten years of sobriety. So I've beaten the odds on both of those counts. The last physical I had, they said, "You should live to be about a hundred if you just don't do all the things everyone in your family did before you." So I've got another 30 years at least.

The tobacco companies have hidden the truth from the American public. They have lied, deceived, cheated, and caused a tremendous amount of grief and misery. They don't care about our welfare or about our health. They only care about profits. And to me that is one of the most unforgivable sins — to benefit from someone else's misery, simply because of money. I can understand killing for revenge or jealousy. But not greed. I can't understand that. And that's what they've done, for years and years. I don't blame the tobacco farmers; they're on the bottom of the food chain. The ones that are at the top of the food chain are the manufacturers and the CEOs. Those are the ones that have manipulated the truth.

They [tobacco companies] have so far been able to litigate their way out of almost everything. They have money. They have *big* money. And they have lawyers, *teams* of lawyers that are tenured into the company and on their payroll. And all they do is call them up and say, "We've been hit with such and such a suit. Go handle it." And that's it. That's the last the CEO hears about it. So they've insulated themselves quite well. And they've used the law, I think, in a very obscene way to get around the truth that they're wrong and guilty as charged. But they can tie it up in court so long that a person can't afford to continue. That's how they get away with it.

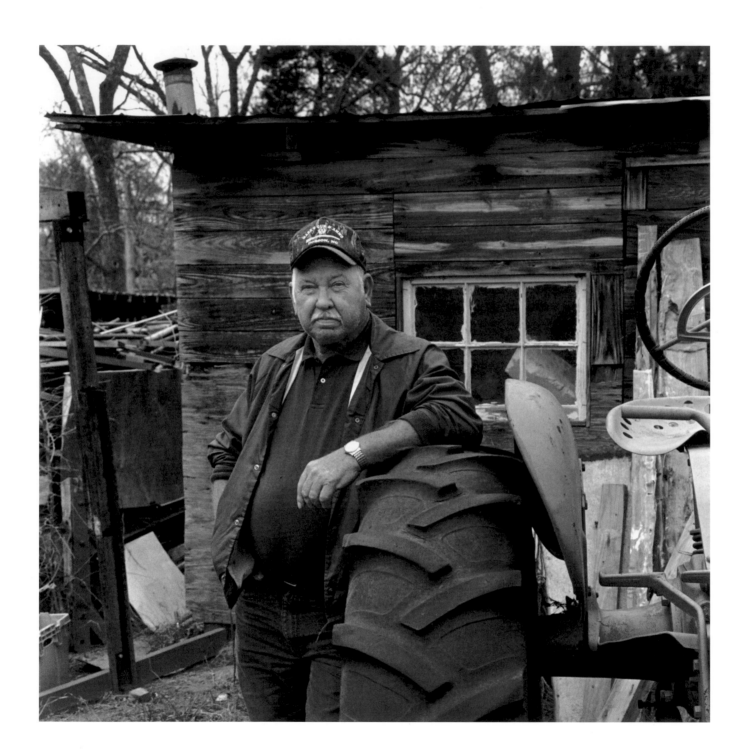

George Phelps

GEORGE PHELPS OF CLEMMONS, NORTH CAROLINA, GREW UP SURROUNDED BY TOBACCO. His great-grandfather, grandfather, father, uncles, and neighbors all grew it. He did, too, for 30 years. He also began smoking at fifteen, consuming about two packs a day until he was diagnosed with laryngeal cancer in 1986. Phelps tried smoking after his surgery, but quit when he found that all it did was make him cough. After that, he got out of growing tobacco entirely. He still chews tobacco to satisfy his nicotine addiction.

❧

It was 1986. I was 47. It got to where I couldn't hardly talk. The doctor was treating me for laryngitis, for about three months. But it kept getting worse and worse. And then I broke down and went to a throat specialist. He walked in the door and said, "How're you?" As soon as he heard my voice he said, "I know what's wrong with you." He took a biopsy and found the cancer. It was part of the way around my throat. By the time he got to it about three weeks later, it had growed just about around my voice box. So he was gonna go in there and take it off, but when he got in there, it was almost around it. So he had to take the whole thing. He took all them lymph nodes out, too. I never had no chemo, no radiation, not anything. I went to a speech therapist and after about three weeks he said, "I don't think you need to come back." But there are some people who been going there three, four, and five years, and they speak worse. It made me feel bad about them, but I just picked it up quick. I wasn't gonna let my wife out-talk me.

That's when I throwed my cigarettes away, after the surgery. I just wadded 'em and throwed 'em in a trash can. I tried smoking one and went to coughing, and I said, "The heck with this." I was back in the bedroom and had a brand new pack, and I walked up to the kitchen and throwed it in the trash can. Just quit cold turkey after that.

We farmed off and on all my life. We quit tobacco a couple years before my surgery. We had young-uns coming on, both of us were working, and it was too hard on us to keep it up, growing tobacco. But I kept working in it for a while after that. And then when this cancer come on, that's when I decided to just get out of it altogether. The doctor told me the cancer come from drinking liquor. But I ain't never been bad to drink. Had maybe a beer once in a while. So it either had to come from smoking or from welding. Probably both.

Hell, I know smoking's not good for people. But it's something that if they want to do it, they're gonna do it. I can talk my head off to somebody, and if they don't want to quit, they ain't gonna quit. But for me personally, I don't want nothing to do with it. It don't bother me if they smoke, but I just don't want to start it back. I don't know if it would affect me now as much as it would before I had my surgery, 'cause the smoke wouldn't get down in there. All I could do is pull it in a little bit. I still chew, though; about a pack a day. You want a chew?

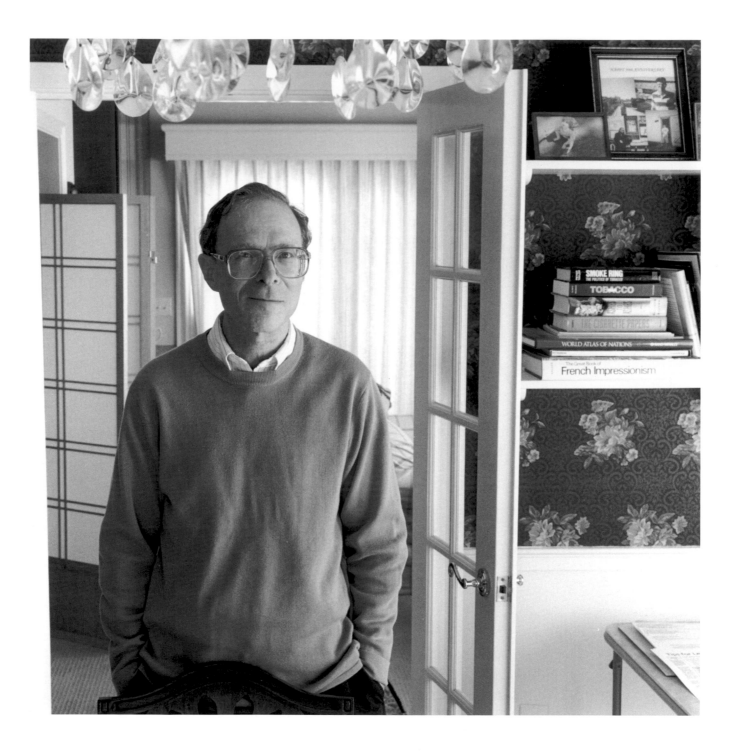

Pete Hanauer

PETE HANAUER, BORN IN 1939, IS ONE OF THE HISTORIC FIGURES IN THE EARLY TOBACCO-CONTROL MOVEMENT in the United States. Hanauer received the Luther Terry Award in 1986 for his role in getting smokefree air laws enacted in California in the late 1970s and early 1980s, and in helping to create the organization that later became Americans for Nonsmokers' Rights. Hanauer is also one of the co-authors of *The Cigarette Papers* (University of California Press, 1996).

∾‿∽

The nonsmokers' rights movement totally cuts across political and social lines. We had right-wing Republicans and Green Party-type people on the campaign from the beginning. We used to joke at our meetings that we couldn't talk about anything except smoking, otherwise somebody would get mad at somebody. There were gun control people and NRA people. It ran the gamut on a lot of issues. That's always been true [in this movement]. The tobacco industry liked to paint the San Francisco ordinances as an anomaly, because San Francisco is this far-out leftist city and these laws couldn't work anywhere else. Well, what they couldn't ignore, though they tried, was the fact that these kind of laws have been passed all over the country, in all sorts of communities, with varying degrees of right- and left-wing perspective.

I was naive at the beginning. I'd never dreamed that the tobacco industry would come into California, much less a local town, and fight an ordinance or a state law. I thought it was just an issue between smokers and nonsmokers — and nonsmokers' right to breathe was more important than a smoker's right to smoke. And I thought this was so self-evident that there wouldn't be any problem. But it didn't take long for us to realize that the industry was going to fight this tooth and nail. The more I saw what they did, and the more lies that they told, the angrier I got. When I accepted the [Luther Terry] award I said that there were two rules I always followed, the only two rules you need to know to fight the tobacco industry. One is, whatever is good for public health is bad for the tobacco industry, and what's good for the tobacco industry is bad for public health. The second rule is to realize that the difference between the Mafia and the tobacco industry is that the Mafia has a code of ethics.

Being involved in the movement has been a rewarding experience. It's been very exciting, because I've gotten to meet a lot of interesting people and do a lot of interesting things. But it's also been exciting from the standpoint of seeing the fruits of my labors. I feel very lucky — and most of us agree who were in on the ground floor — that there are a lot of movements that never get very far, and we have. We can think back to when everybody smoked in elevators, and now no one would dare. I gave a talk in 1976 in which I said, "Twenty-five years from now people will be amazed that anyone ever smoked in restaurants." Well, I was wrong, but I wasn't far from wrong, because that's basically what's happened, at least in a large percentage of the country. So it's been great. You couldn't ask for a more rewarding social movement. It's been a labor of love for me.

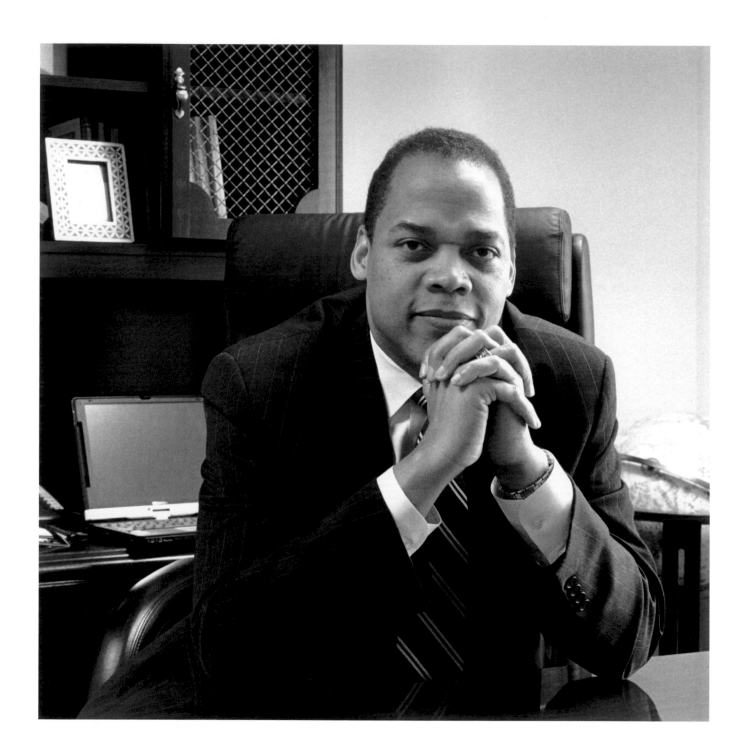

Michael Smith

MICHAEL SMITH OF ATLANTA, GEORGIA, IS A THORACIC SURGEON WHOSE AREA OF RESEARCH EXPERTISE is early detection of lung cancer. Smith noted that most lung cancers begin to grow five to seven years before detection, so early screening can save many lives. The main obstacle to effective screening, according to Smith, is not technology, but cost. His mother, a long-time smoker, died of lung cancer eighteen days after being diagnosed.

❧

As of 2006, most health plans don't require, or even suggest, chest X-ray as a screening tool for lung cancer. That's based on a lot of research that is now being called into question. But the long and the short of it is, they won't pay for a screening chest X-ray. So the dirty little secret is that people just come up with symptoms, like the onset of a cough, if they want a chest X-ray. Then they can get it paid for. But the sad part is that, on a lot of patients, you're not going to see early cancers with a chest X-ray. The CT scan is much better technology.

Over half the people we diagnose with lung cancer are former smokers, people who had already quit, like my mom. Many of them had quit five to ten years before they were diagnosed. I am a big proponent of smoking cessation. We *should* try to get people to quit. But the best available data says that once you hit that 20 pack/year threshold — a pack a day for 20 years — you have a high risk for lung cancer, and that risk stays high for two to three decades. Primary prevention — getting people never to smoke — is important, as is getting people to quit. But smoking cessation alone is not a good way to prevent death from lung cancer. We also have to talk about secondary prevention.

Every day, about 800 people in North America — Canada and the U.S. — are diagnosed with lung cancer. Of these people, 70–75% are diagnosed with stage-three or stage-four lung cancer. Stage-three lung cancer has a five-year survival rate of about 15%. Stage-four cancer, about 5%. So 70–75% of the people who show up with lung cancer have advanced disease, and their prospects for long-term survival are not good. On the other hand, I know that if I find a stage-one lung cancer, the five-year survival rate is about 60–70%. With stage two, it's about 50%. So, again, the data point to the potential benefits of earlier and better screening.

My mom had been so proud of her son, the expert in lung cancer. I mean, I had been speaking all over the country and presenting papers. My mom knew that I had bragged about the people I thought we had cured by getting rid of the cancer. So, like my sisters, my mom's first response when she got the diagnosis was, "My son is an expert in this. So, piece of cake!" And I said, "No, you don't understand. It's stage four. There's nothing that I can do for stage-four lung cancer. The talks you've heard me mention are all about detecting cancers early so we can cure them." So [her illness] was a very difficult road for me to travel. It was made worse, I think, by the feeling that I had somehow ignored her symptoms. That I had been so focused on lung cancer nationally and regionally that I had not looked for it locally. Part of the legacy my mother left me is that I love every opportunity to beat this disease.

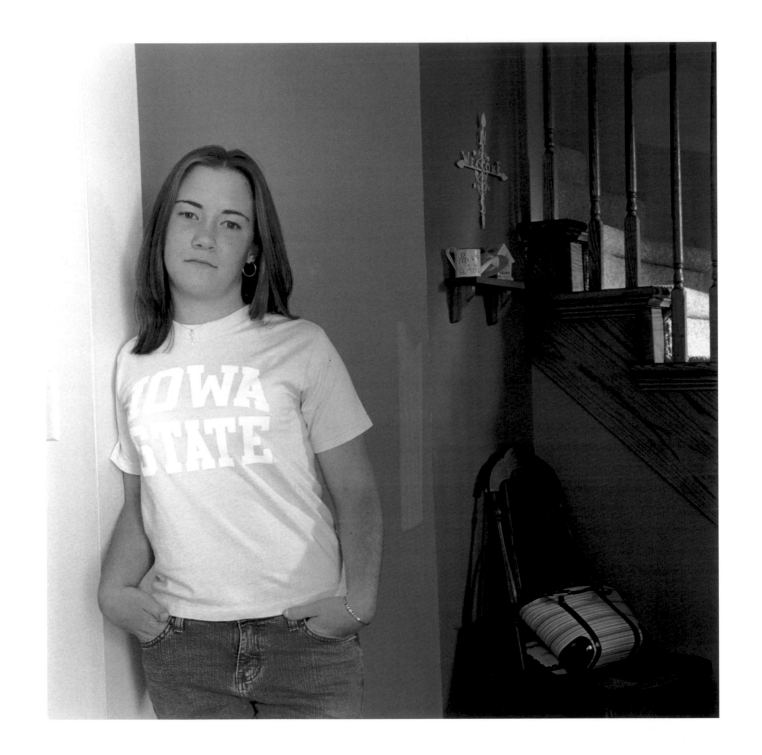

Kassie Hobbs

KASSIE HOBBS WAS IN 8TH GRADE WHEN SHE LEARNED THAT 4,600 PEOPLE IN IOWA DIE from tobacco-related diseases each year. That statistic motivated her to get involved with Just Eliminate Lies (JEL), the state's tobacco-control program for teens. Hobbs went on to become president of JEL, and in 2005 was named Youth Advocate of the Year by the Campaign for Tobacco-Free Kids. Hobbs was recognized for her successful effort to organize teens to lobby their congressional representatives to support FDA regulation of tobacco products.

❧

Forty-six hundred a year is a huge number of people, and it seemed like nothing was really being done about it. So I think it's important that people become more educated and more involved. Like with JEL, we put out commercials and stuff like that. We took a poll last year and 76% of Iowans knew what JEL was and what it stood for, so we are making progress. I also think it's important to have the youth come out and tell about a problem and make people know. Once people know there's a problem, they might want to do something about it.

When I talk to people about FDA regulation, I say that tobacco products are the only drug products not regulated by the federal government, and I say what the benefits would be if we had FDA regulation. Tobacco products wouldn't necessarily be safe, but they could be safer. People would at least be more aware of what's in the products and how dangerous they are. Right now, no one really knows. There's not a description of what's in the product or how dangerous it really is. The tobacco companies just slap "light" and "low tar" on the pack, and that doesn't prove anything. There should be proof behind any claims the companies make. That's what I tell people about regulation.

I think younger people have a special role to play. We kind of play that up, especially when we talk to legislators, because they don't expect teenagers to take time out of their day or their summer to go talk to them. And so we always say, "As concerned youth of Iowa, this is how we feel. This is what we think you should do." We try to get our point across that way. If you get a lot of youth together who care about something, you can make a lot of people pay attention and get a lot done. Most adults think that teenagers just kind of sit around and go shopping or go to the movies and don't really do anything. But if you have, like, a large group of young people who care about something and are willing to try to make a difference, it can have a huge impact.

One thing I've learned is that you have to keep trying, even if stuff doesn't work out. Running JEL has also taught me how to deal with different kinds of people. It's kind of changed the way I look at things, and my whole life, actually. Like, if I didn't do JEL, I wouldn't be interacting with adults and stuff like that. So I think that by doing tobacco control you get a whole different perspective on life. My friends who don't do this kind of thing don't speak at press conferences and meet with legislators. So I feel like it's given me a lot of opportunities. Like, I'm going to school for political science and I plan on doing tobacco control when I grow up.

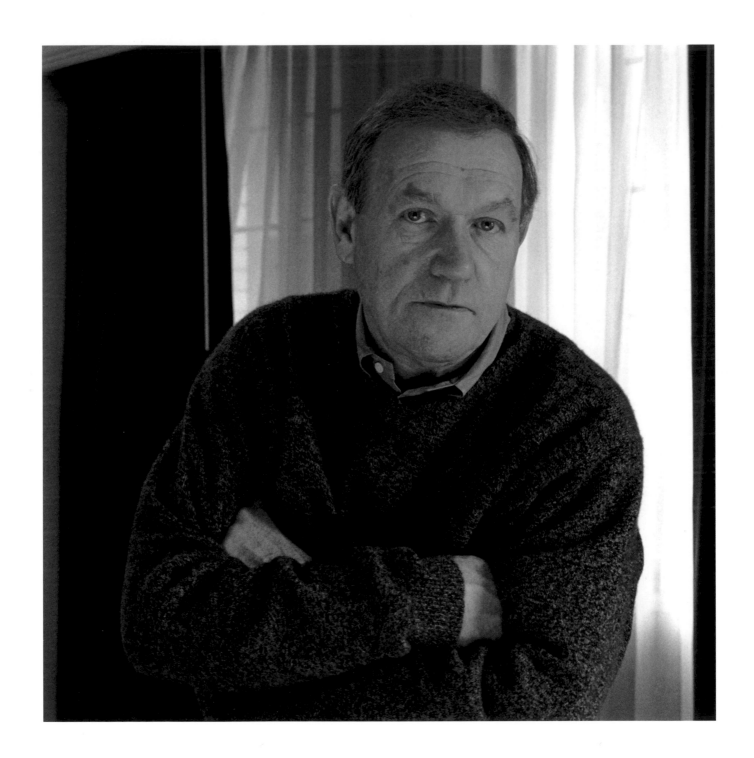

Mike Clark

IN 2002, WHEN MIKE CLARK WAS IN THE HOSPITAL FOR SURGERY TO CLEAR PLAQUE FROM HIS ARTERIES, his cardiologist advised him to quit smoking. This struck Clark as strange advice, since he had never smoked. It was years of breathing secondhand smoke — at home as a child, as a college student, and during fifteen years as a bartender — that had damaged his arteries. After his surgery, Clark changed jobs so that he could tend bar in smokefree Montgomery County, Maryland. His mother, a smoker, died of lung cancer at 58.

~ ~

I had some chest pains while running one day. The next day, it was while walking. So I went in to George Washington Hospital. They did a stress test and some other tests, and they told me I needed to come back within a week for the angioplasty. The next morning they told me I also needed bypass surgery. At the time of the angioplasty, the cardiologist said, "You know, you ought to quit smoking. There's all this plaque in your arteries from smoke." I said, "I don't smoke." He said, "Well, what do you do?" I said, "I'm a bartender." He said, "Well, then you smoke. You're getting secondhand smoke." He says, "You're smoking more than the other people."

Both of my parents smoked. Of course, you know, like I say, I'm 63 years old now. I've been around smoke all my life. In boarding school, everybody smoked. In college, everyone smoked. You know, even though I was an athlete, the other people around me smoked. The *coaches* smoked. My godfather owned a pharmacy. In the back room there'd be two pharmacists and four doctors smoking. If you're around it all the time, like I was in the 70s, you would get used to it. But now there can be long periods where you're not around smoke, and so you just get a whiff of it, down the street, and it bothers the hell out of you.

There are some people who disbelieve the connection between heart trouble and secondhand smoke. You've got the hardcore smokers who believe they're not hurting anybody. With them they think it's a right to smoke. I once had a doctor, he was a guest at the restaurant, tell me that he'd seen no studies that could prove that secondhand smoke was harmful to anyone. The guy was a medical doctor! He was a smoker, too. Thank God he was not somebody giving me professional help.

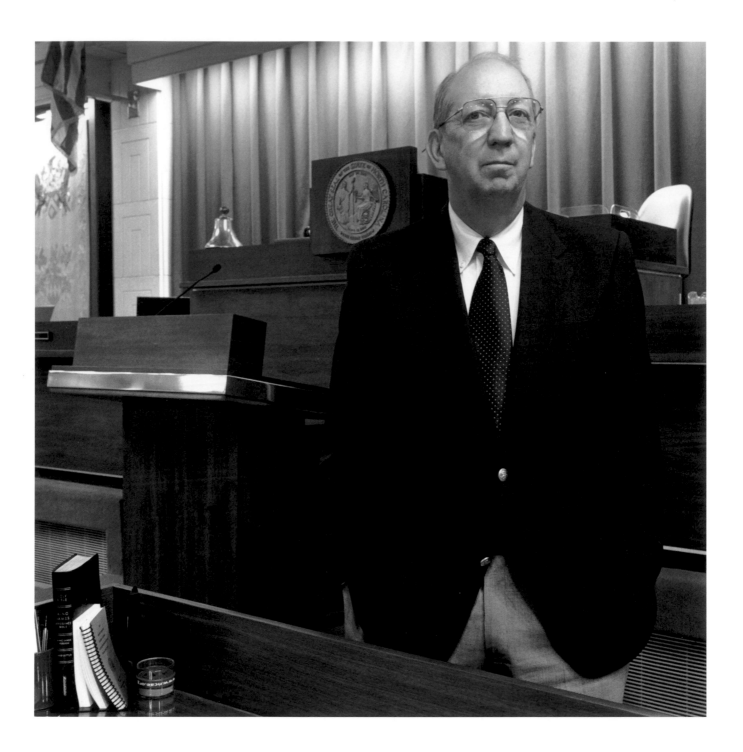

Hugh Holliman

IT TOOK REPRESENTATIVE HUGH HOLLIMAN FOUR YEARS AND FOUR TRIES TO GET A SMOKEFREE AIR LAW through the North Carolina state legislature. The law, covering bars and restaurants, passed in 2009 and took effect on January 2, 2010 (the interview was done in 2006). Holliman's parents were heavy smokers — a fact that he believes contributed to the lung cancer death of his sister, a non-smoker. Holliman himself never smoked cigarettes, but has had two surgeries to remove tumors from his lungs.

❧

I think everyone has a right to a smokefree environment, particularly in public restaurants. I could have made my bill broader, like some states have — covering all workplaces. But I wasn't trying to take on the world here. I eat at a lot of restaurants, and a lot of them have smoking. They don't choose to be smoking or non-smoking. In effect, they choose to be both. They have partitions or latticework, which is worth zero as far as providing a smokefree environment. It's upsetting when you ask for a non-smoking seat and it's not truly non-smoking. I also have a great deal of sympathy for the people working in these restaurants, because people have to work. There may be questions about the science of secondhand smoke, but I don't think there's any question that secondhand smoke hurts you.

I'm not trying to approach it as an anti-tobacco bill. I'm trying to do what's appropriate by way of providing a healthy atmosphere for people who want to go out to eat. I certainly think if somebody wants to smoke, they can go outside and smoke. You know, some people say, "You're discriminating against smokers. What about drinkers?" And I say, "If someone sits beside you and you're drinking, you're not forcing them to drink. But if someone sits beside you and they're smoking, they are forcing you to breathe their smoke." To me, that's a clear difference.

Sometimes I get asked, "Why are you trying to legislate this? Why don't you just let the business handle it?" And I say, "Listen, restaurant owners are trying to make a living, and they're not going to choose to be smoking or non-smoking if they can get away with doing both by putting up a partition." I was in a restaurant in my hometown yesterday. I went out to breakfast and the owner said, "Smokefree is okay with me, as long as you make everybody do the same thing." He said, "You won't hurt my business as long as the people down the street can't allow smoking." I think that's generally the theory of the restaurant owners. We've also done the research. I assigned an intern to research all the smokefree air laws in the country to find out how business had done since these laws passed. And, you know, it's hurt no business at all.

[Smoking] generates a ton of health problems for all of us. If we looked at all the costs we could attribute to smoking, we would probably all say, "Let's be serious and stop." But it takes years to change these things, though they do change. Tobacco lobbyists used to rule the state, and that's not the case anymore. I think that health problems and the cost of the health problems associated with tobacco and smoking are just very big. And whatever we can do to prevent health problems, we should be doing. This bill is a step in that direction. I'm sure there will be many more to come. It's just common sense.

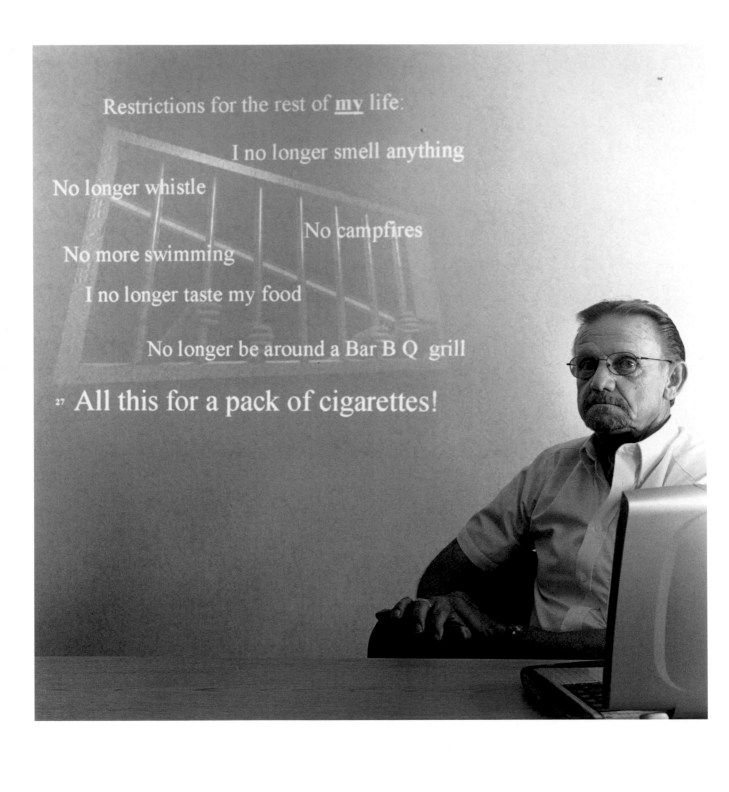

Gary Miner

LIKE MANY SMOKERS, GARY MINER STARTED EXPERIMENTING WITH CIGARETTES when he was twelve or thirteen. By sixteen he was hooked. When he retired from the marine corps in 1986, he was smoking five packs a day. In 1999, at age 53, he was diagnosed with laryngeal cancer and underwent a laryngectomy. Today, Miner uses his raspy voice and stoma to command the attention of school kids, whom he advises to avoid smoking.

⁓ ⁓

In February of 1999, I went to a doctor because I had a bit of a sore throat and an ear ache. He said I might have an infection and recommended that I take Advil once a day. So I did that, but as time progressed I started getting an ear ache almost 24/7, and by June I went to an ENT doctor because the pain was excruciating. I told the ENT doctor that my voice was changing, too. He put the camera down my nose and he pulled the camera back out and looked me dead in the eyes and said, "You have throat cancer. You're probably going to die." He turned around and walked out and let me sit there. I was totally numb. Twenty minutes later he came back in and said, "Now that you got the shock out of having throat cancer, we need you to get treatment right away."

I was scared. I came home and I told Janet that I had throat cancer. After I told her, then I had to tell my kids and then my brothers and sisters and then my neighbors and friends. Then I decided I was going to get a second opinion. So I made an appointment to see another ENT about three days later. He did the same thing. He pulled the scope back out and said, "Well, you have throat cancer but we might be able to save your voice." So he tried to do laser surgery. He got some of [the cancer], but it was also on the folds of my vocal cords and he couldn't get it all. So he recommended that I see an oncologist at UNC–Chapel Hill.

The doctor at UNC scoped me again. He said, "The cancer is on both the false and the true vocal cords and you may have to lose your voice, but we'll do the best we can for you." I still had not stopped smoking. I figured, well, I had throat cancer, and a few more cigarettes weren't going to change anything. And the day that I walked into UNC for surgery I was still smoking, probably five-plus packs a day because I was so nervous. I went into surgery and when I woke up [I found out that] they'd done a total laryngectomy. The doctor told my wife that the cancer was worse than they could see and they had to do a total laryngectomy. But that was four years ago, and I'm still cancer free and going strong.

We have the education now not to use tobacco, but the manufacturers still create advertisements for it because they don't want to lose money. It's David against Goliath, but we will succeed one day. The whole generation will know that tobacco will kill you. And one day tobacco will be a thing of the past. It's like tobacco companies are an elephant. How do you eat an elephant? One bite at a time. It's the same way with tobacco companies. One bite at a time and eventually they'll be gone. That's the way I look at it.

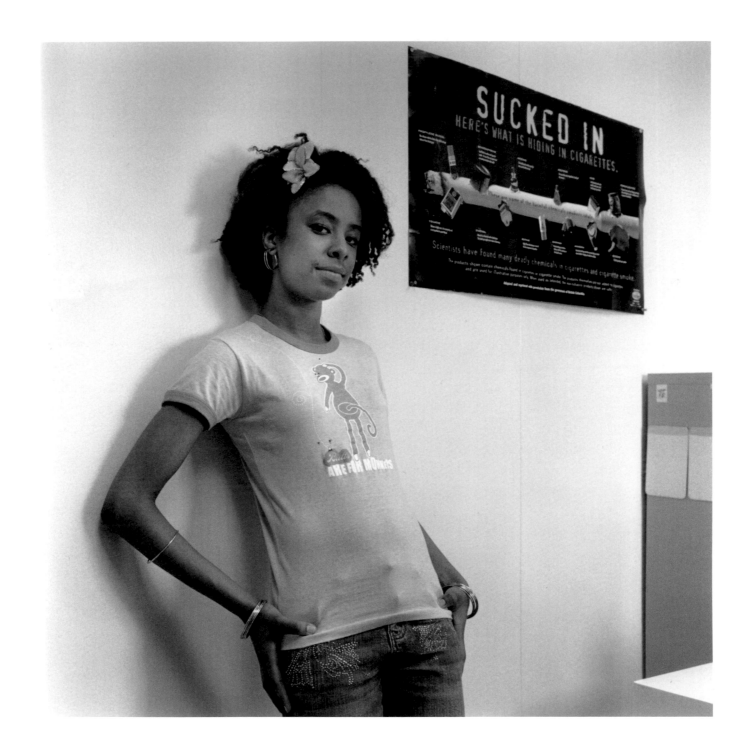

India Hayes

AS A HIGH SCHOOL STUDENT, INDIA HAYES WORKED WITH A YOUTH-LED TOBACCO CONTROL GROUP called Question Why, in Durham, North Carolina. Question Why, which is supported by funds from the Master Settlement Agreement, trains youth groups around the state to advocate for tobacco control policies. The organization also offers workshops in which young people can learn about the health effects of tobacco and about the industry's marketing ploys.

My grandfather, he still smokes. I have uncles and cousins that smoke. A lot of the males. I think I just have one aunt that smokes. But a lot of the males. I think it's because they grew up in the South and they're around it a lot. I've talked to them about it, especially the younger ones, and they're just like, "Yeah, I'll quit some time." A lot of the boys that I know that are going into the army, I think they think it makes them look tougher, look cooler. They smoke a lot.

I have one friend who was really frustrated. She said she had tried to quit a lot of times, and it's like, "I can't get any help," because her whole family smokes. She had family members that had died from smoking and she really wanted to stop. She stopped for about a year, but then when she got really stressed out, she'd go back to smoking. We find that a lot of teenagers will stop and then they'll go back to it. It's especially hard if you have family members that smoke. I talk to them a lot about it and try to help. You know, "Here's my number to call if you need support. Here's some things you can do to stop." You try to be really helpful to your friends.

From working with Question Why, I've learned that change is gradual. You have to really stick to it. But first of all, you have to take action. You can't just say you're going to do something and expect it to happen. You have to really believe in what you're advocating for and really put every effort into making it happen. But we also know that it's not going to be fast. You have to, like, be patient with change. You also have to take other people's perspectives into account. Like, you could be speaking to someone whose family was raised on tobacco money. Or they could be farmers and they know it's wrong, like what they're doing, tobacco farming, but it's the only way they can survive. So you have to understand different people. Probably the hardest thing about it is just being so young. Sometimes people don't take you seriously.

It would be great if youth could come together and be aware enough to form a movement against tobacco marketing. We need a realization that [the tobacco industry] is like an authority figure that is doing something awful to you and does not have your best interests in mind, and that you're not being a rebel by smoking. You're just being played. Just that *awareness* would be great. That would be the solution because, I think, since they're so targeted, youth should take the initiative to stop it. So if that happened, that would be a solution right there, young people.

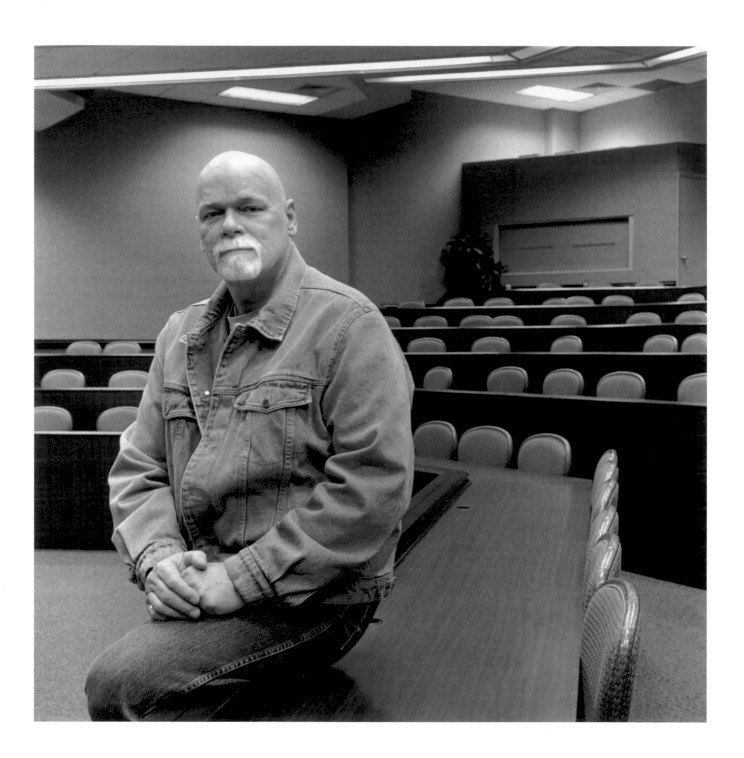

Rick Stoddard

RICK STODDARD IGNORED THE ADVICE OF THE FUNERAL DIRECTOR AND WROTE IN HIS WIFE'S OBITUARY that she died from lung cancer "caused by smoking cigarettes." She was 46, and had died within six months of being diagnosed. A local reporter saw the obituary and did a follow-up story. The story led to Stoddard recording a series of anti-smoking ads for the state of Massachusetts and to a new career as a tobacco-control educator. Stoddard speaks to kids at hundreds of schools every year.

My wife started smoking when she was around thirteen and smoked all the way up to the end. Like other smokers, she was addicted. You know, you can't wait till you get cancer and then decide to quit. It's too late then. If you think you've got six months to live, quitting smoking is about the last thing on your mind. A lot of kids ask me, they say, "Rick, when Marie was diagnosed with six months to live, what did you guys do? Did you, like, take an exotic vacation? Where'd you go? What'd you do?" In fact, we sat at home and held hands. I would hold her hand, that was it. You reach a point where — it really brings into perspective what's important in your life. Taking a trip wasn't it. Talking about smoking wasn't it. We were doing everything we could just to keep her alive and comfortable as long as we could.

Eventually, because of the seizures, she lost the use of her right arm and right hand, which took away her writing and her artwork. That was very hard for her. Losing her independence was another big thing. Her mobility; she lost the use of her legs. I watched the disease take everything from her. I watched a really gifted and kind and caring person literally wither away to nothing. That's what I want people to understand. You don't just smoke and get cancer and die. Before it kills you, it takes everything from you. I mean everything, and *then* it kills you.

A reporter in New York once asked why I do what I do. And I said, "I do it because I feel I have a moral obligation to stand up against a product that kills 1200 Americans every day." I said, "In fact, it's everyone's obligation, including yours." And I said, "Did your newspaper report yesterday that 1200 people died in this country from tobacco-related illness?" He said, "No." I said, "If anything else killed 1200 Americans today, would it be on the front page?" He says, "Yeah, probably so." I said, "What's the difference?" "It's old news," he says. And I said to him, "You tell the kid who came up to me after my program yesterday and cried her eyes out because her dad's dead from lung cancer that it's old news. You tell my thirteen-year-old grandson that it's old news, and see what you hear from him. You tell my son that it's old news, and see what you get out of him." Old news? That's just a poor excuse to cover up for an industry that kills 440,000 Americans every year. Somebody has to come out here and tell the truth about this stuff and not candy-coat it and not smooth anything over. You can't rely on political leaders to do the morally right thing. So guys like me have to suck it up and leave my family and head out on the road and try to get as many people as I can to listen.

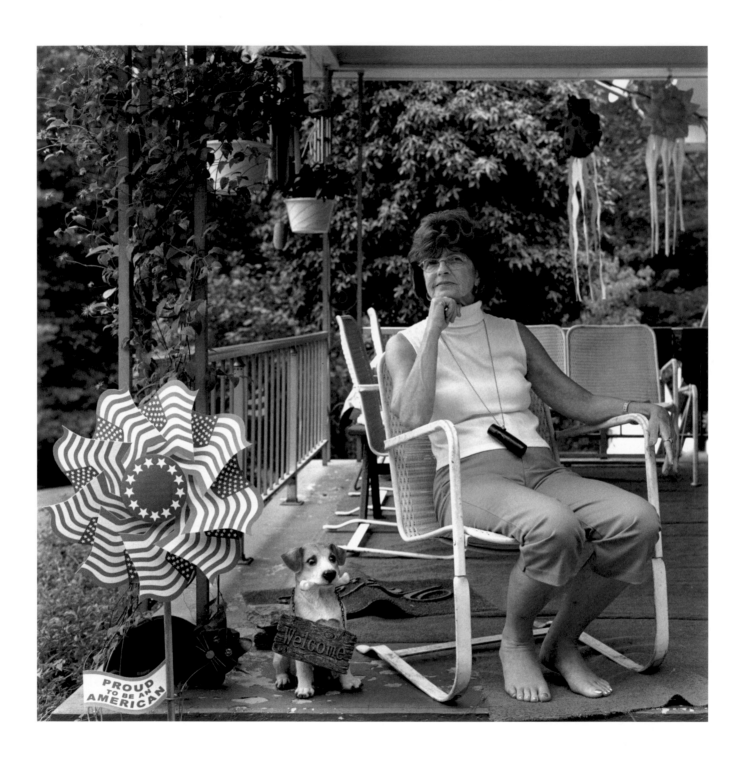

Rachel Biddix

RACHEL BIDDIX WAS SEVENTEEN WHEN SHE AND HER HUSBAND MOVED TO NORTH CAROLINA. New to the area and without a job, she spent her days watching soap operas. "All my soap opera stars smoked on TV, and they advertised [cigarettes] as a way to be like them, so I started smoking," she said. It was 1958. Biddix smoked until she was diagnosed with laryngeal cancer in June 1999. After overcoming depression and learning to use an electrolarynx, Biddix began giving anti-smoking talks in middle schools. Biddix died in September, 2007, after her cancer recurred.

It was in 1998, in December, around Christmas time. I thought I had a sore throat, so I went to the doctor. He said, "Sore throat. You need antibiotics." Well, in January I wasn't any better. So I went back to change the antibiotics. This went on through January, February, and March. Then they thought it was allergies. But I knew I was sick, because I didn't feel good and I began to lose weight. My throat hurt from my throat to my ear, and I kept saying, "If it doesn't get better, I'm just going to cut my head off."

By May they'd tried six different antibiotics. They just weren't reaching it, they said. They still thought I had an infection. So they said come back in June. Finally, I said no. I said I'm going to a specialist and find out what's going on. So I went to a specialist and even he dismissed me. He said, "If you stop smoking, it'll get better." And I said, "Well, you gotta prove that to me. There's gotta be something." And he said, "Okay, let's use the light." And he put the light down and said he saw enough to want to do a biopsy. He did the biopsy. And during the week while I was waiting for results I prayed constantly: "Oh, God, please don't let it be cancer. Please don't let it be cancer." And I was thoroughly convinced that it wouldn't be.

There was a lady at my church, and she said she'd had a cyst on her voice box and all they did was go in and cut it off, and that was all there was to it. I was convinced I was her. I was going to be her. I was not going to be the cancer person. But when I went back, he said, "Rachel, you've got cancer." And I said, "No, I don't. You're lying. I will not let you lie to me like that, because I know that God won't give me cancer. I prayed and he answered my prayer." And the doctor said, "Yeah, he answered your prayer, he just didn't answer it the way you wanted it answered." And I said, "But he would not give me cancer."

It took me a while to realize that God didn't do that to me. It was the tobacco companies and myself gave me cancer. Me, for smoking. Them, for not telling me in the beginning how bad cigarettes were. Them, for increasing the poisons that go into cigarettes. So it was a combination. It wasn't God. It wasn't my husband, who brought home those samples. I blamed him for a while. If I'd had a *dog*, I would have blamed it. I didn't want to take the blame. But actually the fault lay in myself and in the tobacco companies for being so late in warning people and increasing the amount of poisons. It was nicotine that got me addicted, but it was the other ingredients that gave me the cancer.

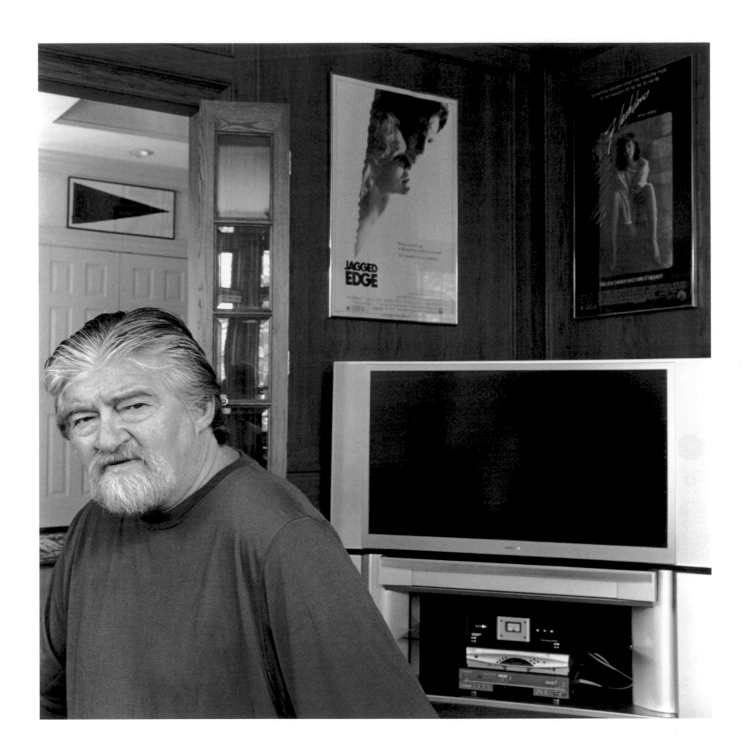

Joe Eszterhas

JOE ESZTERHAS WAS BORN IN HUNGARY IN 1944 AND IMMIGRATED TO THE U.S. WITH HIS PARENTS IN 1950. He grew up in Cleveland, worked as a reporter for the *Cleveland Plain Dealer*, and went on to become a Hollywood screenwriter. His best known films are "Jagged Edge," "Flashdance," and "Basic Instinct." A self-described "militant smoker" who intentionally glamorized smoking in his films, Eszterhas changed his views when he was diagnosed with throat cancer in 2001. "What I did was wrong," he said. "And I'll do my best to correct it." He now works with the Cleveland Clinic to help people stop smoking. He also seeks to get smoking out of the movies.

❧

I was horrified by the fact that I had cancer, and I was frightened. But it was like the addictions in my mind overwhelmed even that. It was so difficult for me to think of living a life without cigarettes or alcohol, because I'd had it every day from the time I was twelve and fourteen years old. They were the absolute crutches that no one really knew about, and they'd been there since I was a boy. In any situation that had any stress to it, I'd smoke a cigarette and have a drink. So I didn't really know what was going to happen in my life and how I'd be able to function without those two things.

I felt that smoking was an individual choice, that people knew that it was going to harm them and that if they wanted to go past that, then it was up to them. I didn't believe that secondhand smoke hurt people. I thought it was a myth conjured up by the PC police. Then in the course of my own illness I met an eighteen-year-old boy who got throat cancer. His mother was a chain-smoker, and there was no other reason he could have got throat cancer. She was a three-pack-a-day chain smoker. He was always around her, all of that. And that changed my thinking.

A lot of times when I was writing, I would drink, and smoke constantly, of course. When I was younger, I drank a combination of black coffee and cognac. Then when I turned about 45 or so, I'd sip white wine as I wrote [and smoked]. Well, to approach the page, the blank page, without anything, when you're used to having those substances to write with, it petrified me. And for about six months, I had real problems. But I just stuck with it day to day and finally found that I didn't need those things to write with. Now, I very rarely have a cigarette craving when I'm writing, and never an alcohol one, but sometimes a cigarette craving. Then I stop writing and go outside and run around a little bit.

It's the most difficult thing in the world to stop smoking, and that's what frightened me so much. There were moments that I didn't think I could, because it's — well, now they say that it's more difficult to stop than it is for a junkie to kick smack. From what I went through, where I felt every single nerve-ending on fire and this desperation to get this thing, this *feeling* back — I understand it. That's why — and I feel the exact same way about the drinking — that's why, you know, I will take it day by day until it ends, and I will keep looking over my shoulder.

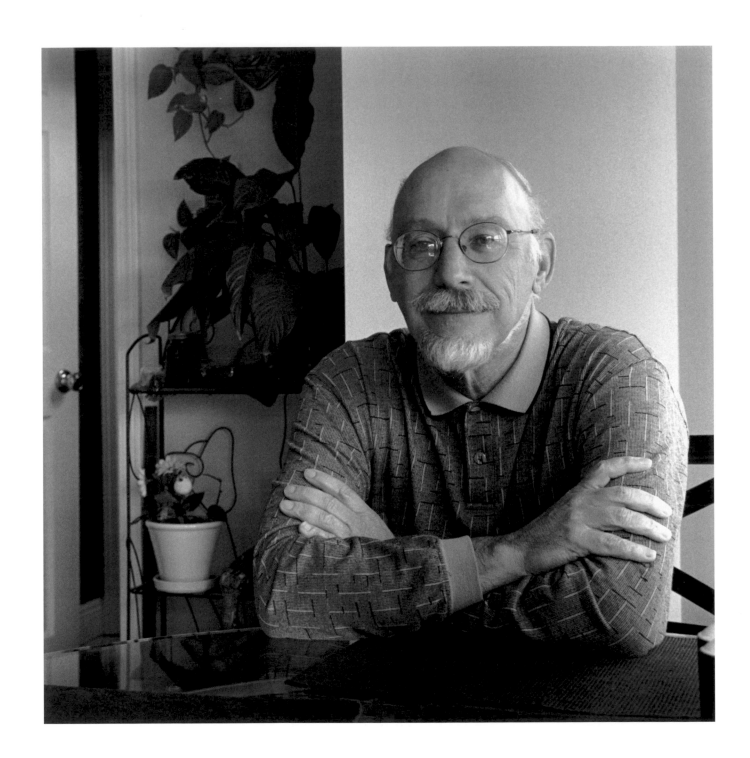

Don Shopland

DON SHOPLAND BEGAN HIS CAREER FRESH OUT OF HIGH SCHOOL BY DOING LIBRARY RESEARCH for the surgeon general's historic 1964 report on the health effects of smoking. Four years later, Shopland moved to the National Clearinghouse on Smoking and Health (later renamed the Office on Smoking and Health). In 1987, the National Cancer Institute hired Shopland to coordinate its smoking and tobacco control program. He retired from the NCI in 2001. Shopland's father, a long-time smoker, suffered from laryngeal cancer and later died of lung cancer.

❧

On [January 11, 1964, the surgeon general's report] was printed and done. The Government Printing Office handled it as a secret document, like something from the Pentagon, because it was a very sensitive topic. Everything was kept under lock and key. They didn't want information to leak out early because they were afraid of what would happen to the stock market. Cigarette stocks were a major commodity back then. A lot of other industries could be affected as well. Agriculture and paper. Additive makers. Advertising and promotion, too. They all would have been affected. That's why the report was released on a Saturday. They wanted to make sure that the stock markets were closed when they released the report.

One thing we've shown over the years is that people do tend to respond to the tobacco issue if you pay serious attention to it. So public education campaigns, if designed properly and done in the right way, could continue to eat away at smoking prevalence. But these campaigns are now really expensive because you can't just run public service announcements anymore. You've got to do paid advertising and make sure that people are exposed to those messages. And who's going to fund this on the scale it needs to be done? I think directing ads at teenagers has its place, but if you're going to concentrate only on teenagers, can you wait years to see an effect? Whereas we know that if we can get adults to quit smoking, there will be an immediate effect on mortality. The risk of heart disease is cut in half the first year after someone quits smoking. That's significant. The other problem with concentrating solely on kids is you've got to keep going back to each generation. You've got to keep redoing the message. It's a continuous battle.

Changing the social environment is the key. There is a lot of evidence that shows that if you can change the way society thinks about smoking, you can change behavior quite rapidly. One component of this is huge excise taxes on cigarettes. Make the tax as large as you possibly can. The second thing is, get rid of smoking in all public places — restaurants, bars, casinos, and every place else. And the third thing is an aggressive public education campaign that hits hard, in terms of talking about the health risks of smoking and telling people they really need to quit.

What you learn in school is maybe 10% of who you are. You have to get out into the real world to learn your limitations and your potential. Then you learn by doing and by being exposed to stuff, and this is more important than what you learn in the classroom. If I had gone to college and missed working on the surgeon general's advisory committee, I probably would have ended up in business administration. Or, maybe if I was lucky and got a Ph.D. in something, I might have ended up happily doing research somewhere. But I probably wouldn't have had the life-enriching experience that I had.

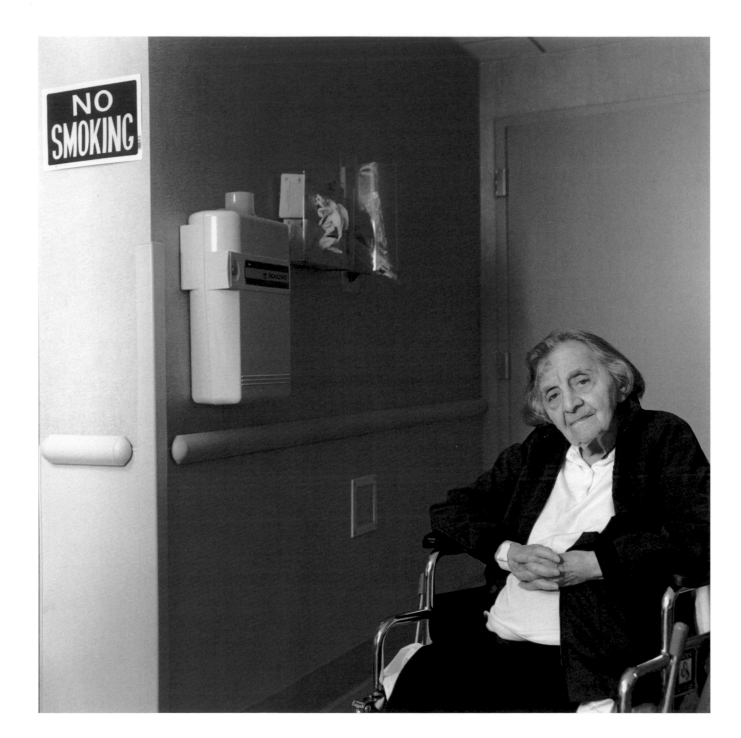

Ann Paulson

ANN PAULSON GRADUATED FROM BROOKLYN COLLEGE IN 1939 WITH A DEGREE IN PHYSIOLOGY AND HYGIENE. In the 1990s, she became involved with Joe Cherner's campaign to pass smokefree air laws in New York City. Paulson posted anti-smoking stickers on bus stops and newspaper dispensers. She also organized a letter-writing campaign among residents in her apartment building. Paulson was two months shy of 87 when I interviewed her in 2004.

❧

I knew that over 400,000 people a year died from tobacco. I knew that 10,000 a year died from alcohol — also a good cause [to work on]. But I knew that putting alcohol and guns and six other health problems together did not come anywhere near tobacco, in terms of the damage it did to people. It also bothered me that each year 400,000 relatives went crying all the way to the cemetery while the tobacco companies were laughing all the way to the bank. Today, they have problems with lawsuits and everything, but they had a clear field then. And I thought, what am I going to do, spend my efforts on something that kills 10,000 people or something that kills 400,000? And that's how I decided to put my efforts into the tobacco issue.

We worked on the smokefree workplace campaign for about ten years. At first they said there'll be smoking sections and non-smoking sections in restaurants. But that wasn't a solution. We wanted a law that would protect all the customers who went into bars and restaurants, and we couldn't get it through. Then Joe [Cherner] got a brainstorm. He realized it was crucial to get workers involved. That's when everything changed, when workers began testifying. Joe's fantastic. One thing doesn't work, no problem — he thinks of something else. We learned from what didn't work, and went on to do what did work.

The law we passed in New York has worked well and people are happy with it. I live in the East Village and we have lots of wonderful ethnic restaurants. I love to go, but because of the high rents, the restaurants all had to have bars, and with the bars, people wanted to smoke. This meant the owners could pay their rent but non-smokers didn't want to go. Now they found out, after we got the law passed, that their business got better, not worse. That was one of the turning points. Other states saw what happened, and now they can't use that argument anymore, that businesses will be hurt, because we have proof that, as we say, "Smokefree workplaces are good for health and good for business." That's our mantra now.

Once I went to have a mammography done, and the woman who was doing my mammography came in limping. I said, "What's the matter?" And she said, "Oh, I hurt my foot." Or maybe it was her knee. And she said, "Well, I'm not as young as I used to be. I don't heal as quickly." So I looked at her and said, "How old are you?" She said, "Thirty-two." I said, "You're in your *thirties* and you feel old?" I said, "I'm 80 and I never know what they mean when they say you 'feel old.'" I have no time to feel old. I'm too busy.

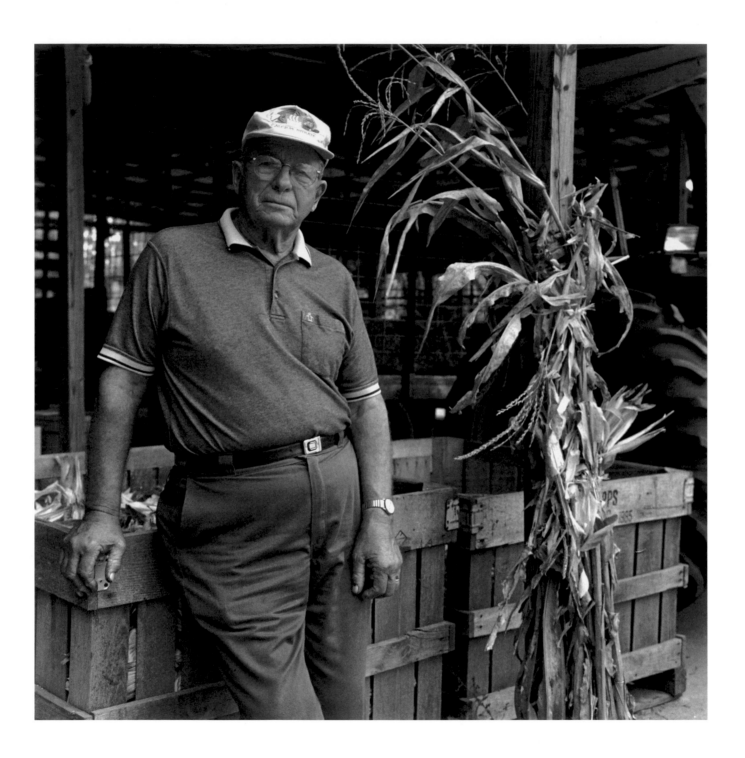

O. K. Bellamy

FOR THREE GENERATIONS, BEGINNING IN THE 1800S, O. K. BELLAMY'S FAMILY GREW TOBACCO. Many of the people in his family smoked the product they grew. Then, in one week in 1973, two of Bellamy's wife's sisters, long-time smokers, were diagnosed with lung cancer. At that point Bellamy decided to stop growing tobacco and shift his production to vegetables. His farm in Calabash, North Carolina, is still thriving, now run by his son and grandchildren.

My uncle was a preacher and he grew tobacco and he used tobacco. Said he chewed tobacco all the time near 'bout when he was a young man. Said one day he was walking down the road and a voice told him "Chap"—see, his name was Chap—"if you don't quit this tobacco, it's going to be your ruin." And he thought, well, if the Lord's telling him not to use tobacco, he better quit. That was before he was a preacher. But he quit and would warn other people that it's wrong. That didn't bother me so much, but then my wife had two sisters diagnosed with cancer the same week. They were heavy smokers. She had three brothers that was diagnosed with cancer. All three of them were heavy smokers. Five in her family died with lung cancer. And that told me something. And my conscience was bothering me and one day I was thinking about it and I decided to quit. Quit growing it.

I liked the smell of tobacco. When tobacco was cured in the barns—see, we stayed there all night and used wood to cure it. When the leaf got to drying out real good it had a good odor to it. Later on, when I'd get around two or three boys, they'd pull out a cigarette and I'd smoke one, maybe once in awhile. It didn't do anything for me. When I went to Clemson, my roommate, he chewed tobacco. We was sitting there one day and he had chewing tobacco. He said, try some. I tried it and it made me sick. So it just never was the thing for me to use tobacco.

The church, the Wesleyan Methodist, would not allow a preacher to grow tobacco, but a friend of mine was a preacher and he was growing tobacco. And they made it so hard on him that he quit the church and went somewhere else. There was a Sunday school teacher who was a big tobacco grower, and they got on him. He said he prayed and was sick about it, but he never would quit tobacco. He never did teach anymore. I mean, it just destroyed his teaching. The body is the temple of God, and so you're supposed to watch out for the health of the body. That's the reason for the church's position. But you won't hardly hear anything about that now. Just about all the churches have got so modern that they don't want to touch the issue. They want to keep peace with everybody, so they don't say much about it.

I was a Sunday school teacher, too. And when my wife's sisters was diagnosed with cancer and one of them died not too long after that—well, one day when I was thinking about it, and something just tore away and I knew I had to leave tobacco alone. That was my cash crop. That was a hard decision. And I never have regretted it. I think it was the right—well, I *know* it was the right thing to do.

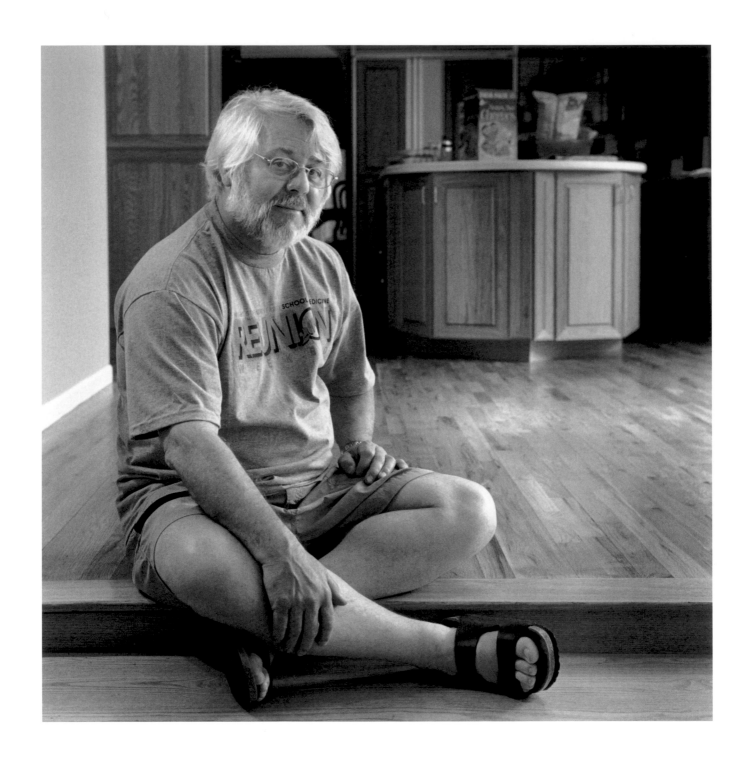

Jeffrey Wigand

AS RESEARCH DIRECTOR FOR BROWN & WILLIAMSON, JEFFREY WIGAND HOPED TO HELP THE COMPANY develop a less toxic cigarette. He was fired in 1993 when he rebelled at the company's practice of allowing lawyers to control its scientific communication. Wigand's appearances on "60 Minutes" in the mid-1990s, and his later legal depositions, helped to bring about the Master Settlement Agreement in 1998. The 1999 Hollywood film "The Insider," starring Al Pacino and Russell Crowe, was based on Wigand's story. After leaving Brown & Williamson, Wigand became an award-winning high school science teacher and also founded Smoke-Free Kids, Inc.

❧

[There's much more to be learned about the industry's] lawyer-client fraud — about how the lawyers who worked for the tobacco industry created fraud on the American public by destroying documents that could have led to better health and safety. They abused rules of civil procedure by not producing documents that were requested in litigation. Go back to the Cipollone case. If Marc Edell had the documents that we have today, what would have happened to Rose Cipollone? Those documents were asked for and never produced. [The tobacco companies] abused the attorney-client privilege. They abused their ethical canon as officers of the court. And they haven't been disbarred. How many tobacco executives today or lawyers that were neither disbarred or — well, a lot of Enron executives are going to jail for stealing money, but there's not one tobacco executive going to jail for killing anybody, or for lying under oath. And so my mission is to hold them accountable.

If people [thought more philosophically about harm], we would have a different perspective on the way we deal with tobacco. The problem is, drugstores sell it because it makes more money than selling drugs. To me, the pharmacist ought not to be pushing nicotine patches in one corner of the store and Marlboros in another. To me, that's a disconnect. ... [With the money from the Master Settlement Agreement] we've given the states opportunities to do the right thing, the morally right thing. I'm not saying take all [the money]. There's a formula. [The recommendation is that] 20% of the settlement funds go for tobacco prevention. We know that every dollar of prevention saves us $3.00 in productivity and healthcare costs. Why would I not, as a businessman or businesswoman, understand that by reducing tobacco consumption in my state, I would be reducing my overall healthcare burden and increasing my productivity? And, at the same time, saving lives. Would that not be a categorical imperative?

Juries still believe it's the smoker's choice and responsibility and therefore they're not due compensation. That says they don't really understand, because most of these people didn't start by making a rational decision. They started when they were eleven to thirteen years old, when the idea of death and sickness was very remote. But the idea of being manipulated for money and being tricked has a lot of resonance. So my approach [with kids] is to give them tobacco industry documents to read. "We don't smoke this shit. We reserve it for the dumb, black, and poor." Who said this? It's an RJR executive. I ask, When? Why? "Let's make the girl think that she's going to get thin." Project 16. Project Plus-Minus. Let them read about it in the industry's words. And I use the documents a lot, even with 3rd, 4th, and 5th graders. They've got to read and give a report, and then they've got to teach it. If this was done universally, I think it would work. I really do.

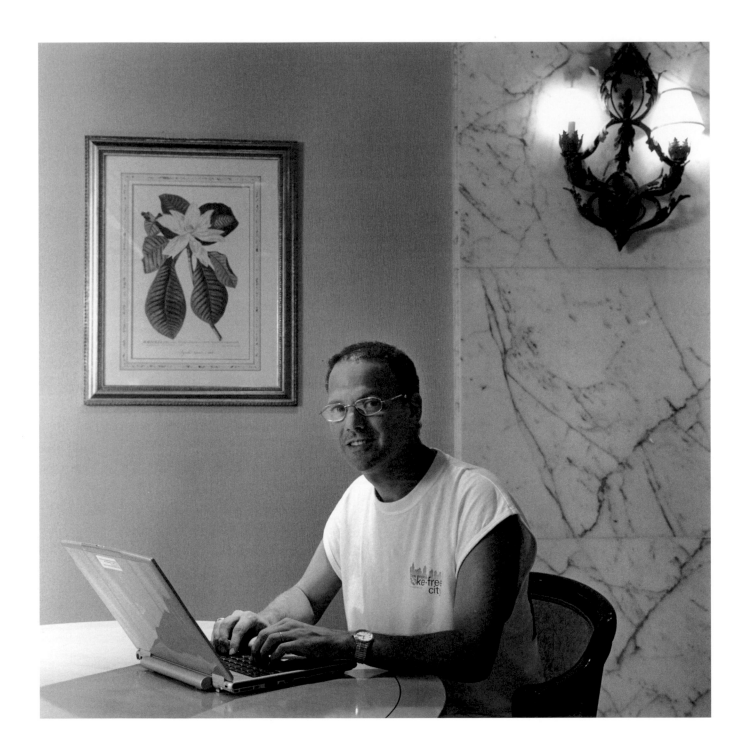

Joe Cherner

BY HIS EARLY THIRTIES, JOE CHERNER HAD MADE ENOUGH MONEY AS A BOND TRADER AT KIDDER, PEABODY that he could retire and devote himself to activist work. In 1987, he founded Smokefree Educational Services, which was at one time the largest anti-tobacco advocacy group in the country. Cherner is credited as being the driving force behind the grassroots efforts to pass New York's stringent smokefree air laws, to outlaw cigarette vending machines in the city, and to ban tobacco advertising on subways.

∽ ∾

I don't think anyone doubts that eventually all workers will have the right to a smokefree work environment. It's pretty much common sense that nobody should have to get sick to have a job, and nobody should have to breathe something that causes cancer. Smokefree workplace legislation is clearly a matter of dignity and respect for workers, and all workers are going to get that dignity and respect eventually. I think even the tobacco cartel knows that. They probably know it better than anyone, because in some places that time has come already. In some places that time has not yet come, but it will come. The only question is when.

In the beginning, we didn't know if smokefree air laws would be good for business or bad for business. But now that more than a hundred jurisdictions that have passed smokefree air laws, you can't say that it's bad for business with a straight face anymore, because there's too much data out there to show that clean air is actually a good thing [for business]. If they claim it isn't, they don't have an economic leg to stand on, because the data is conclusive.

People are recognizing that we're fighting for the right to breathe clean air, and that's been a dramatic change, probably the most gratifying of all the successes we've had. It used to be that people thought we were trying to take away someone else's right to smoke. They see now that that's not the case. It just so happens that the right to breathe and the right to pollute can't co-exist peacefully. And so government is going to have to decide which right is more important, because when you put two people in a room, one who wants to breathe clean air and one who wants to smoke, you can't accommodate them both. And governments all over the world are deciding that the right to breathe should prevail over the right to pollute. So for me, the most significant achievement is getting people to understand what we're fighting *for* and not what we're fighting against.

Politicians have to hear from workers, especially from pregnant workers. A visibly pregnant waitress or bartender can explain what it's like to breathe smoke for an eight-hour shift and go home coughing her lungs out, knowing that she's jeopardizing her pregnancy. There isn't anyone who can't understand that that's unfair, particularly when she explains that she doesn't have a college education, that she can't get another job, that she likes her job, and that she makes good money at it and needs that money to feed her family. And her choice is either going home coughing her lungs out while she's pregnant, or being on the street homeless. It's pretty easy to understand that she shouldn't have to breathe smoke.

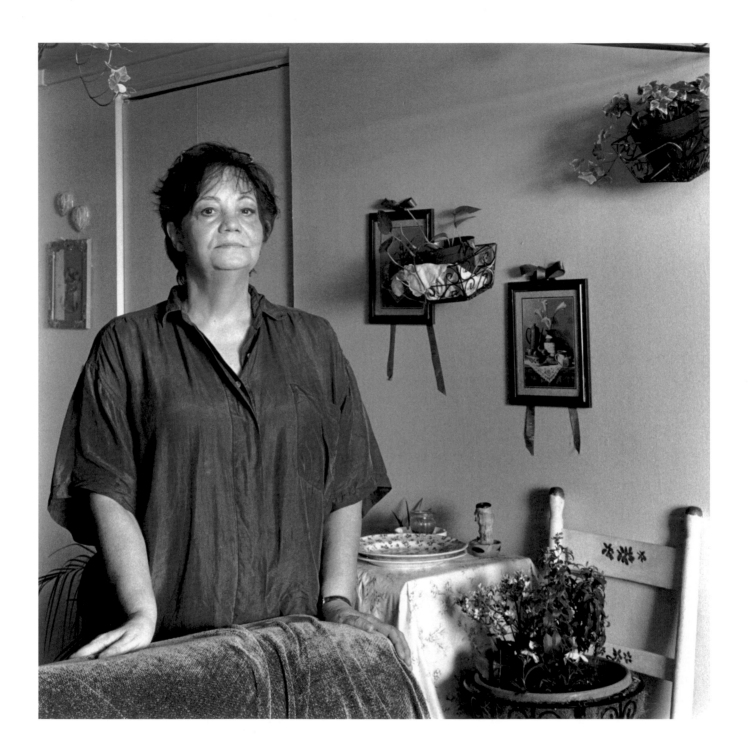

Shirley Burchard

SHIRLEY BURCHARD'S MOTHER SMOKED FOR 40 YEARS, STARTING AT AGE SIX. She quit at 46, when she began experiencing chronic bronchitis and symptoms of emphysema. Burchard's mother died at 63, after being disabled by emphysema during the last years of her life. Despite witnessing her mother's decline and other tobacco-related disease in her family, Burchard still struggled to overcome her own nicotine addiction.

 ◦ ◦

My mother started smoking — remember, in those days it was touted as good for you. She told me that she started smoking when she was six years old. My aunts and uncles also started young. They passed away with — my aunt passed away with breast cancer but the other ones passed away with heart attacks. Two weeks after my mother passed away, my brother, who was 42 at the time, had a massive heart attack. He was a smoker. The undertaker said, "This is the best looking corpse, the most physically fit corpse, I've ever seen come through here."

One time I went to visit my mother and she was coughing so bad she was shaking. And I said, "What's wrong?" And she said, "It's the cigarettes. I've gotten bronchitis with it." And she was just hacking and hacking. She went through that every morning for about two hours. The doctor laid it down to her and told her she had to quit smoking, and she did. But she continued to hack like that, right up until she died. Towards the end, she couldn't lay down. She had to sleep sitting up in a chair. We tried everything to make her comfortable. It was impressive that she quit smoking, but a lot of damage was already done.

I smoked for nineteen years and then quit for eight years. It was hard. I would dream of it. I would wake up and I was like — in my dream, I was holding a cigarette. It would wake me up because I never smoked in bed. At my peak, I was smoking a pack a day. I quit for eight years and then went back to smoking. You would think — I saw the effects. I saw my mom go through it. I mean, it was awful. It was plain awful. It doesn't matter how educated you are, how smart you are. I know about it and I know I need to quit. But yet I'm doing it because I'm addicted to it.

I started modeling at fourteen, when I was in junior high. I did it part-time when I was in college, even up into my thirties. So I was in shape, taking care of myself. I was doing three miles a day, walking. I wasn't prone to drugs in my youth. I did party a bit. When I say "partied," I mean like three drinks. So it's not like I'm predisposed to addictions, and yet with this one I felt like I was coming out of my skin. I mean, it was very, very hard. There wasn't a day that I didn't want a cigarette. I just don't think [the tobacco companies] should have done this. Once they knew better, they shouldn't have done it.

My mother used to say, "I'll tell you what I've done is, I've let the devil in." She'd say, "I've let the devil into my life. These cigarettes are the devil." She'd cuss like a sailor when she talked about the tobacco company bosses. She'd say, "Those goddamn sonsabitches. They ought to be strung up by their nuts."

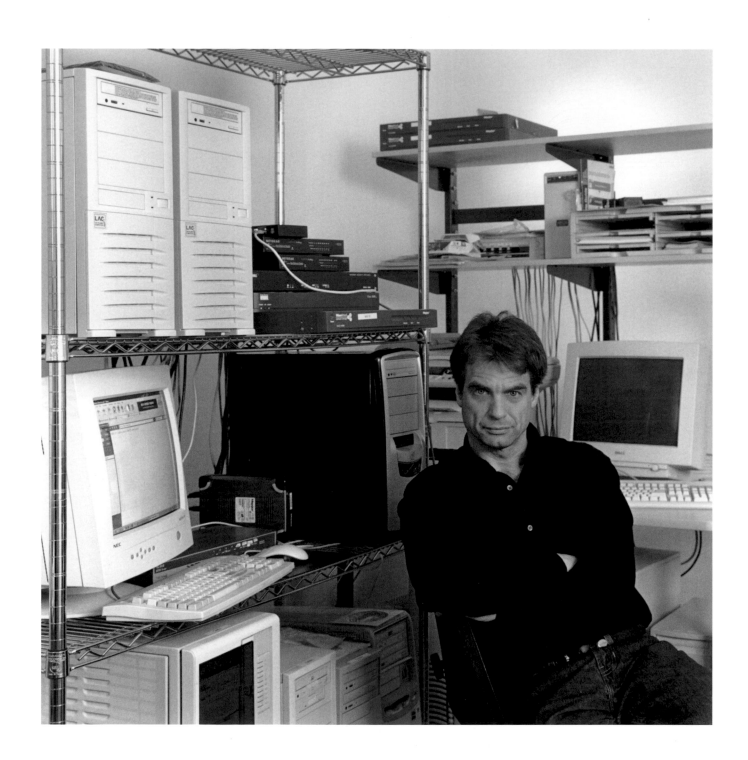

Mike Tacelosky

THE INTERNET HAS BECOME ONE OF THE MOST VALUABLE TOOLS OF TOBACCO-CONTROL ACTIVISTS, and Mike "Tac" Tacelosky, born in 1962, has been the tobacco-control movement's Internet guru. Using the wealth derived from the sale of his first software company, Tac has underwritten the movement's principal information websites: *Tobacco.Org* and *Smokefree.Net*. He was also co-founder of SmokefreeDC, the grassroots organization that was instrumental in passing smokefree air laws in Washington, D.C.

❧

When I graduated from college and started flying for work, there was still smoking allowed on airplanes. I hated it. There were times on long flights when it made me really sick. About ten seconds after takeoff you'd hear "ding" and then see this Pavlovian response. People would immediately start lighting up. There was this nonsense — they'd say, "You're in the non-smoking section." And I'd think, Are you stupid? Or do you think I'm stupid enough to believe that if there's somebody smoking ten feet away that I'm in the "non-smoking" section? I know that was the line the flight attendant was programmed to give, but for so long we deceived ourselves about "non-smoking" sections, in airplanes and restaurants and other places.

We know from industry documents that the tobacco industry fought against even segregating smokers in airplanes. They said, "Someone should be allowed to smoke in the seat next to you. It's not a problem. People are just going to have to learn how to live with each other." They fought against smokefree air measures, because they knew that once people got used to smokefree environments it's pretty easy to extend the principle to other places. As soon as smokefree airplanes and offices came in, people started thinking about smokefree restaurants and bars. And now it's like, "*Of course* smokefree. It should be everywhere."

The tobacco industry is clever and has done a great job of framing this — of trying to make sure that the press uses the word "ban," as in *banning* smoking, when they write about smokefree air laws. But we're not banning cigarettes or banning smoking. We're just moving it outside. The language matters, because if you ask people, "Do you support a smoking ban?" you're going to have more people say no than if you ask, "Do you think all workers deserve a smokefree workplace?" So it's important to make sure that people use the right language.

I have the ability to sort of do whatever I want with my time, which is an enormous blessing, and there's an obligation that goes with that. If I know that I have enough resources to do whatever I want, then I'd better be doing something worthwhile. I'm also lucky to have a business partner who knows that my passion is fighting big tobacco and using technology to do good in the world, and that I'm going to be spending time and energy on this. I probably work too much, but I like doing the technical work, doing something that nobody else could do. I like it that we've been able to create this technical infrastructure for the movement. We've made [tobacco news and industry documents] more accessible, and made it easier for activists to communicate with each other. The archives we've created are used constantly in legislation and litigation and education. I can't take all the credit for that, but it's nice to feel like I've made a real contribution.

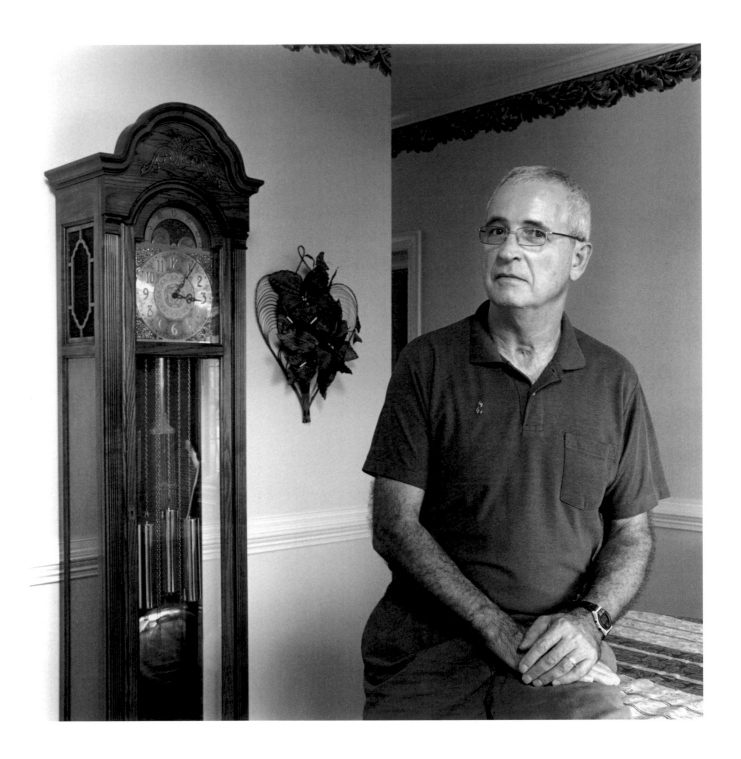

Steve Shakal

STEVE SHAKAL WAS ONE OF THIRTEEN CHILDREN BORN TO A FARMING FAMILY IN WISCONSIN. At fourteen, he left home to begin working on his own. When he was diagnosed with lung cancer in June 2000, Shakal was 57 and had been smoking for nearly 40 years. In 2006, after radiation, chemotherapy, and surgery, Shakal was one of the 15% of stage-three lung cancer patients who live beyond five years. Shakal volunteers as a cancer counselor and helped form the group North Carolinians Against Lung Cancer.

❧ ❧

I probably accepted the cancer as a consequence of smoking. I knew what it said on the stupid cigarette package. But what I told myself was, "I've been smoking these for *decades*. I'd be *dead* by now if that was true. If I was sensitive to those kinds of problems that are written on the cigarette pack, if it was going to affect me, it would have affected me by now." That's what I told myself. That's how I gave myself permission to have another cigarette.

For years I would work, go home, eat, sleep, and go back to work. Finally, I thought, I've got to do something, so I started running. I'd set the alarm early and go out and run — about two miles in the morning. I even used a heart monitor to make sure I was getting good exercise. Then I'd shower and go to work. And I thought, Yeah, I smoke, but it's no problem, because I run. I thought if smoking really bothered me, I couldn't be running, see? That was what I told myself: "I can smoke, because I run." What a stupid idea.

I was misdiagnosed in 1999. I had back pain that I thought was caused by how I was using the computer at work. I felt it on weekends, when I'd be puttering around the yard or playing with the kids. The pain was toward the center of my back, and it was easy to ignore because it would come and go. But then my wife said I should go to the doctor and get it looked at. The first doctor I saw said, "I think you've got a muscular spasm. You need to work out." So I did physical therapy for six weeks and it wasn't making any difference, so I quit going. I thought I was just getting old. I also had a little cough. But if you're on cigarettes, you get coughs; they come and go. Then I went to another doctor and he looked at me and heard my cough and ordered a full set of X-rays. Then I saw a pulmonary guy. He looked at everything and said, "Steve, you've got lung cancer. It's advanced. It's incurable. It's inoperable." Fortunately, he wasn't right about everything.

At first I was mad. I thought, I worked my ass off all my life, and this is what I get? I thought I was going to decay and turn into a vegetable and my family would just be waiting for me to die. It was excruciating to think about becoming dependent and being a pain to have around. But then I thought, I have to give treatment a shot — for the people who care about me. Much later, after I got over being enraged at being dealt a bad hand, after I hit bottom and started coming up a bit, spiritually, I got a notion and said, "You know what? As mad as I am, I'm actually very lucky to still be here. This is my chance to help people."

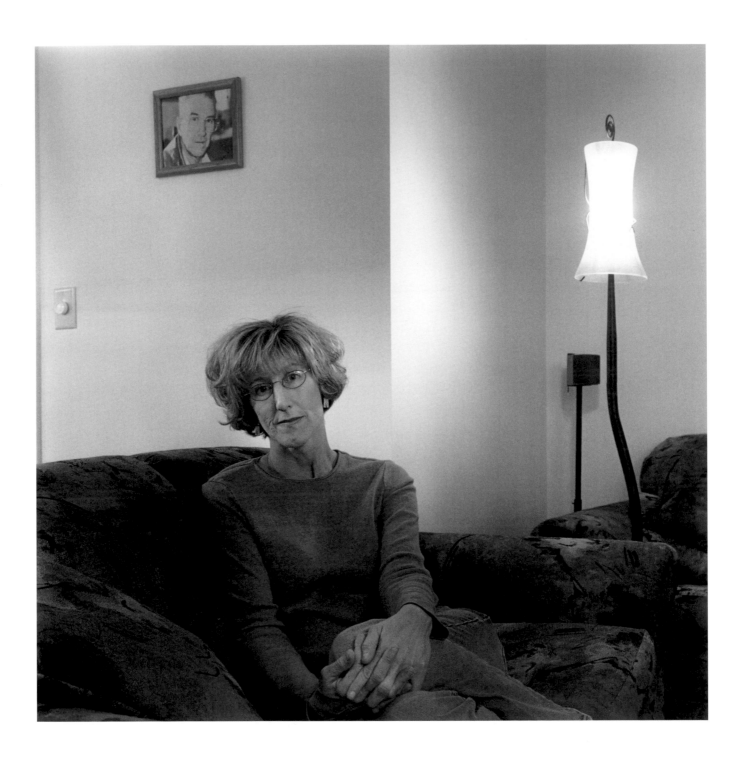

Nancy Nadbourne

NANCY NADBOURNE'S FATHER STARTED SMOKING WHEN HE WAS THIRTEEN. At 67, he developed a mysterious lower back pain. The pain, as it turned out, was caused by a lung tumor. The cancer had already spread, and Nadbourne's father died two months later. One of Nadbourne's grandparents and two of her uncles died from tobacco-related disease. At the time of the interview in 2003, she was still trying to quit smoking.

❧

In January of 1994, my father started having lower back pain. He otherwise seemed healthy. He could run up and down the stairs twenty times and not be winded. My mother, she was a non-smoker, and she couldn't do that. So all of us kids, there were six of us, we would say, "Mom's probably going to die of lung cancer from secondhand smoke. Just watch, she's going to be the one to get sick, not Dad, because he's a rock." And so he went to the doctor in January and had chest X-rays and they found nothing. He still had the pain in March so he went back, and again they didn't find anything. So he keeps going to the doctor and then in April, all of sudden — and this is what blew my mind — all of a sudden it's stage-four lung cancer. Not stage one. Stage four.

The biggest heartbreak for him — I told you at one point all six of us smoked, and at this point the three girls and one boy smoked, so four out of six of us still smoked. And it broke his heart because he couldn't do anything to help us at that point. He said when he was young they didn't have the warnings like they do now, from the surgeon general, and they didn't realize back then the dangers of smoking and tobacco. And he said, "I brought this on myself. If only I hadn't started." His big thing was, "I brought this on myself." I remember him saying that. And he was just in tears, wanting his children to quit smoking.

My sister and I say we know we're going to die of cancer, because it runs in the family and we're still smoking. I don't know what the odds are for me now, having smoked for 32 years. But I have a tremendous amount of guilt, especially with my ten-year-old son begging us not to smoke. He is just now learning the word "hypocrite." I can say, "Don't you ever pick up a cigarette." And he'll say, "Don't worry, Mama. I'm not going to smoke." He hasn't yet come around and said, "Hey, wait a minute. You can't tell me not to smoke. You guys do that." But that day is coming. Thankfully, he hates the smell of it and has no desire to touch it. He thinks it's nasty and disgusting, and I pray that he continues to feel that way.

I was fortunate that I had time to get to know my parents as adults, and I look forward to having that opportunity with my child. It's going to be great when we get to that stage. But I know that with every cigarette I'm robbing him of another day of that. So it's an internal struggle. I know I need to quit smoking. I know that's the best thing for me. You'd think that after watching my father deteriorate — watching the pain and suffering he went through and what it did to him. I mean, that's what my sister and I say. God, you know, what else will it take?

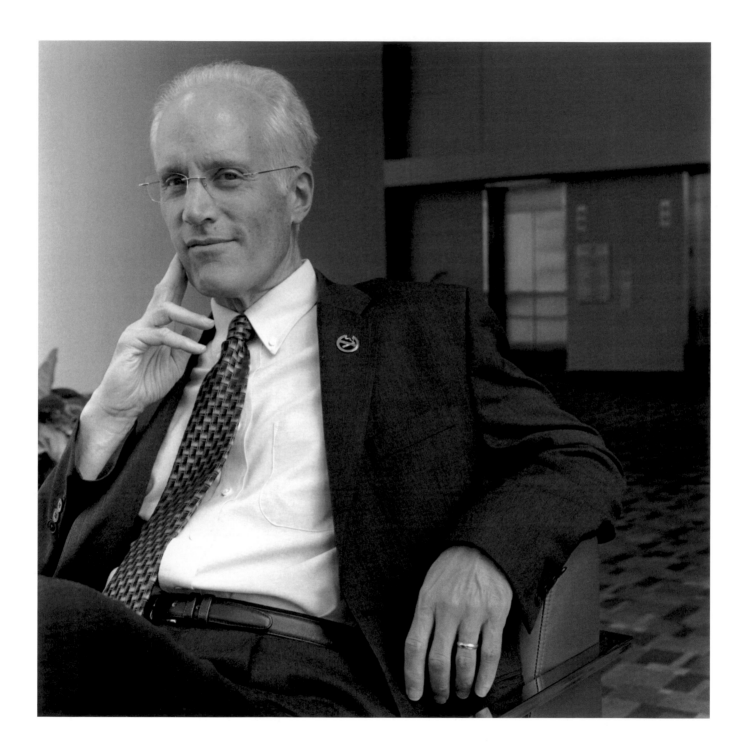

Ken Warner

HEALTH ECONOMIST KEN WARNER HAS BEEN DEAN OF THE SCHOOL OF PUBLIC HEALTH at the University of Michigan, chair of the editorial board of the journal *Tobacco Control*, president of the Society for Research on Nicotine and Tobacco, and director of the University of Michigan's Tobacco Research Network. In 1981, when Warner was directing a study funded by the National Center for Health Services Research, former U.S. senator Jesse Helms wrote to Health and Human Services secretary Richard Schweiker asking him to cut off Warner's funding.

❧ ❧

I have what I consider the best of all possible academic positions. I have the freedom of academia to do what I want, to define the job pretty much. But one of the things about academia is, there's a lot of game playing. If I'd been in a traditional economics department, which was where I thought I was heading originally, I don't think I would have made it. I don't think I would have been able to stomach it after a while — trying to best the other person by coming up with a fancier mathematical model or whatever. But the neat thing for me about [my tobacco research] is it gets attention from the outside world and has an impact on policy. Some of the stuff I did on tax helped to convert people's thinking from "tax is not a good policy for affecting behavior" to "raising taxes is something you have *got* to do for tobacco control."

The critical issues are in the developing world. There's Eastern Europe, Asia, and several other places where there are high smoking rates, particularly among men if you look at the Asian countries. The rates are high and nobody's trying to quit, because they don't know it's dangerous. And then there's Africa where, with the exception of South Africa, smoking rates are still relatively modest. Prevalence is fairly high among males, but you're talking about one or two cigarettes a day. And so there still is time to forgo the epidemic. It's really remarkable to think there's a place on earth where we could do that. Research in these countries is critical, because they aren't going to pick up the U.S. surgeon general's report and be convinced that something is bad for them. They need to see it in their own data. So, unfortunately, you do need a lot of reinventing of the wheel country by country.

I don't think [the tobacco] industry is fundamentally different from any other industry in terms of what it's trying to accomplish. I think the difference is what they've been *allowed* to accomplish. I'm an economist and I very much believe in the free market. But the free market only works if there are rules that the competitors have to comply with and those rules are enforced. In the case of tobacco, we've totally dropped the ball. So it isn't really the industry that we can expect to heal itself or fix itself. It's *us*. It's *our* responsibility to make sure that they do what they're supposed to do, and we've chosen to ignore them and let them go off and do whatever they want to do, so they're doing exactly what you'd predict. Someone at this morning's [conference] session was talking about their leaders being evil people. Well, maybe they're evil. But, if so, they're evil in virtually every major corporation in the country, because the leadership is interchangeable. They go from one industry to another, and it makes no difference what the product is.

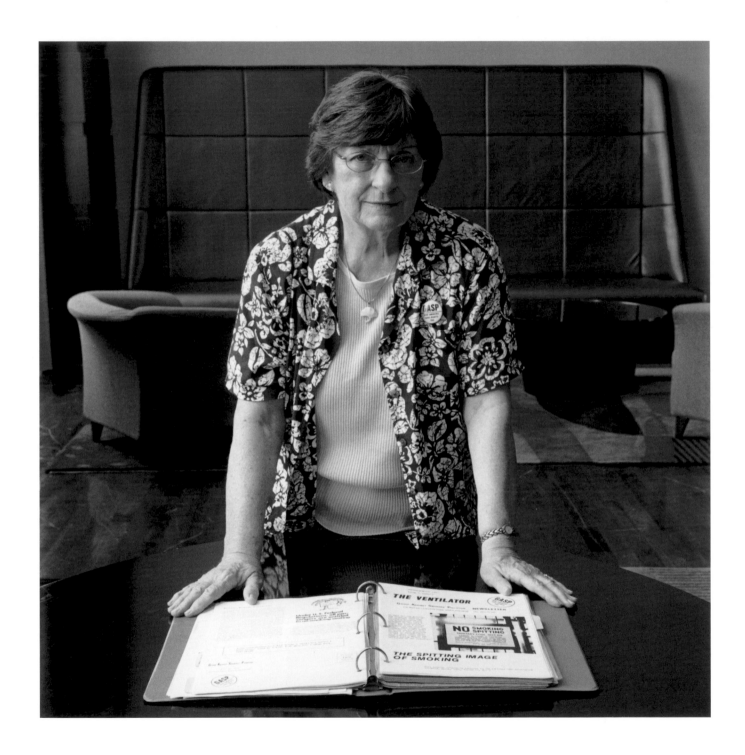

Clara Gouin

IN FEBRUARY OF 1971, A YEAR AFTER HER CHAIN-SMOKING FATHER DIED AT 58 FROM COMPLICATIONS associated with lung cancer, Clara Gouin organized the first meeting of what came to be known as GASP (Group Against Smokers' Pollution) in her living room in College Park, Maryland. Within a few years, 150 GASP chapters were formed in cities across the country. Today, owing largely to the movement launched by Gouin, 32 states and 3,117 municipalities in the U.S. have smokefree indoor air laws.

❧

My father was never one to complain about his health. In fact, he always told us that smoking kept him from getting colds or the flu because cigarette smoke killed the germs. That was his theory. I think what happened was he started gradually getting short of breath. My mother noticed. He was re-wallpapering the house and she came in one time when he was doing one of the rooms, and he was leaning against the wall, trying to catch his breath. She knew something was wrong and she insisted that he go see the doctor. Our family doctor examined him and said he had spots on his lungs. He had actually stopped smoking about a year before this happened.

My non-smoking friends and I often groused about having to put up with smoke everywhere. They were parents, and someone would say, "The PTA meeting was so smoky last night that I had to wash my hair when I got home." Then someone else would say, "Someone was over at my house smoking, and I haven't aired it out yet." It was that type of thing. We just griped about things like that. But what was really the genesis of everything was that I was very sad that my dad had passed away. He was only 58. The doctor told me after the surgery that he had about six months to live, and that's just about what it was.

At the time I thought, There's nothing you can do to stop people from smoking; they know it's harmful but they keep doing it. The government agencies and the health organizations can't do anything, so what could I do? I felt frustrated by it. But then I got to thinking about how so many of us were griping about other people's smoke. When we would take our daughter to the restaurant, she'd get all congested and fussy and we wondered why. It was the tobacco smoke. So I thought, Why don't we all get together and at least try to protect ourselves from the smoke? I thought, I have a lot of friends. I'll get them together. We'll form a group. We'll distribute buttons and put out posters. The next morning I said to myself, "The name of it's going to be GASP and we're going to have a newsletter called 'The Ventilator.'" Once in a while, your brain gets on a roll.

The tobacco industry's gimmick was to make smoking appear popular. They used this to get people hooked. But we thought, What if we don't have smoking where people gather? Then maybe people will give it up because they'll see that it's unpopular. If we banned smoking indoors — in stores, theaters, churches, and what have you, maybe people would think, Hey, I'm not going to be so popular if I smoke. They would just also be restricted from smoking in certain situations. We know now that this has had an impact on smoking rates.

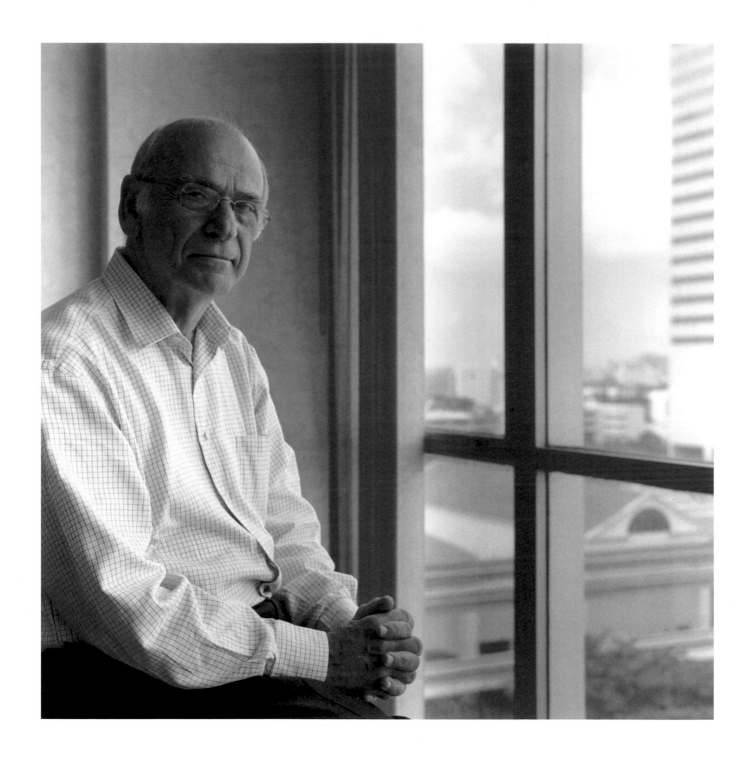

Stanley Rosenblatt

IN 1997, ATTORNEYS STANLEY AND SUSAN ROSENBLATT WON A $349 MILLION SETTLEMENT in a class-action suit against the tobacco industry on behalf of airline flight attendants injured by secondhand smoke. Soon thereafter they brought another class-action suit against the five largest tobacco companies in the U.S., this time on behalf of 700,000 Floridians who were victims of tobacco-related disease. In July, 2000, in *Engle v. Liggett*, a jury agreed that the tobacco industry had, for seventy years, sold a deadly, addictive product and lied about its dangers. The jury levied the largest punitive damage award in U.S. history: $144.8 *billion*. Lawyers for the industry appealed the verdict, which was overturned by an appeals court ruling that decertified the class on the grounds that each smoker's case is unique and must be tried separately. In July 2006, the Florida Supreme Court upheld the appellate court's decision, voiding the jury award.

∽ ∽

What originally intrigued me was the possibility of taking the depositions of the CEOs of Philip Morris and R. J. Reynolds just to find out what these people are made of, because to me, the bottom line, morally and ethically, is that you're making and selling a product that you *know* is going to kill a certain percentage of the people who use it as directed. And I wanted to know how they could live with that. Then in 1994, our pediatrician, Dr. Howard Engle — he'd been a pediatrician in Miami Beach for half a century; he was a very fine and dedicated doctor, and also a chain smoker — developed emphysema. We thought he would make a great plaintiff, and he was willing to do it. By then I had taken the depositions of the CEOs [as part of the suit on behalf of the flight attendants] and I really wanted to get them. So that led to the filing of the Engle case.

When we filed the [Engle] case, our goals were to educate the public about the dangers of smoking, and hopefully to keep another generation from getting hooked, and to give the people who had already suffered some relief. I also wanted to show the tobacco CEOs for what they are. When I took their depositions in 1993, I asked, "Does [smoking] cause lung cancer?" And they said, "We don't know; that's never been proven. It's a risk factor, but there's no scientific evidence of cause and effect." I listened to them lie through their teeth about everything, including addiction. So we wanted to show them up. And I thought that once the American public understood how little the tobacco executives thought of their intelligence, and how easy they thought the public could be manipulated and tricked into using this product, then people would throw up their hands in disgust. But I did not then understand the power of the addiction.

What's beautiful about a long trial is that the jury is not getting snapshots, they're not getting soundbites, they're getting the total picture. And the [Engle] jury basically came to understand that the tobacco industry was a bunch of liars. The jury saw through the lies and the duplicity and realized that their intelligence was being insulted day after day. The jury became knowledgeable, because we had wonderful scientific witnesses. So they knew when they were being bullshitted. And at the end of two years, based on evidence and the law, the jury felt, as Americans with no axe to grind, that these bastards deserved to be punished — with a $145 billion verdict.

Dzuy Ho and Thao Dao

THAO DAO WAS NINE WHEN HER FAMILY EMIGRATED FROM VIETNAM TO THE UNITED STATES. Dzuy Ho was eighteen when his family came over. In 2007, at the time of the interview, Ho and Dao worked as health educators for Vietnamese Social Services of Minnesota. Ho's father, a heavy smoker, died at 48 from heart disease. Dao's father and uncle both suffer from emphysema related to smoking. Over forty-five percent of Vietnamese men are regular tobacco users.

❧

HO: In Vietnam, the woman — before, see, smoking is not a habit formed in the woman, because they say if they see a woman who's smoking, "That's a bad habit," and it gives a bad reputation to the person. But there is now globalizing and social change, so smoking is more powerful. I haven't been back in a long time, but most of my friends come from Vietnam and say it has changed. A lot of women are smoking in Vietnam. The rate is higher than before. Some women, the young generation, they think smoking cigarettes is okay and they have lowered their health.

DAO: In Vietnam, nobody stands up and says, "Hey, this is bad." It's more of a norm, that it is okay to smoke. Over here we've become more educated. We see more diseases are happening and people are dying from smoking. It's still hard to educate people who are older than us. In our culture, this is like telling them that they're not smart enough to know about it. Like, who are we to say, "Here, you have to know about this"? It's hard to get the message to them, because they're old-fashioned and they don't want to change. Most people don't want to change anyway.

HO: Yeah. It's very hard to get people to change their habit. In Vietnam, you give out cigarettes like a handshake to people. In Vietnam, even though I don't know you, if I want to talk with you, I invite you to a cigarette and hospitality. So it is not easy to educate the community and say, "Tobacco is not healthy." Some people, when they come here, some of them become aware about tobacco use and the issues, so they try to quit. The rate here is lower than in Vietnam. In Vietnam, the tobacco companies are spending money to do advertising. I think it's harder for them to make money in the United States, for tax reasons and because more people are aware about tobacco.

DAO: What we think is okay over here is not okay over there, and vice versa. I mean, if kids grow up in Vietnam thinking that it's okay to smoke, it will be very hard to change the way they think when they come here, even at a young age. It's easier to educate the kids who were born here.

HO: Yeah. It's funny. My father-in-law, in Vietnam, he had power. There he can do whatever he wants to do at home. When he came here, now he has to listen to my mother-in-law. When he smoked at home, my mother-in-law would yell at him, about tobacco. So now he quit smoking. Here, the women have power.

Afterword

PATTERNS

The people of *Smoke Damage* are not a representative sample of those whose lives have been changed by tobacco-related disease. I simply sought to include people who came to my attention through news stories or their own writing, or through activist networks, and who seemed likely to have interesting stories to tell. Any generalizations based on the experiences of such a haphazardly composed group should be viewed with caution. There are, however, several patterns that seem clear enough to warrant comment.

Among those who developed cancer related to smoking, the most striking commonality was misdiagnosis or late diagnosis. Coughs and sore throats that persisted for months were attributed to laryngitis, bronchitis, colds, or allergies. Mysterious, unrelenting back pains were attributed to kidney infections or muscle spasms. By the time cancer was found, the situation was dire.

The diagnostic error here, it seems to me, is not one of guessing wrong after looking at all the relevant data. The error is failing to get the data in the first place — that is, failing to do a thorough clinical work-up when *people who smoke or are heavily exposed to secondhand smoke* present symptoms that are possibly related to tobacco-related disease. If this were done routinely, many more cases of cancer could be caught earlier, at more treatable stages.

A related pattern among men who suffered from tobacco-related disease was delayed help-seeking when symptoms persisted. Over and again, I heard from men and of men who had to be cajoled by partners, spouses, or other family members, sometimes for weeks or months, to go to the doctor. This is an old story. Men fear appearing weak and vulnerable, and thus avoid getting help, often until it's too late. If there is a lesson here for men who smoke, it is to scrap the Marlboro Man fantasy and get symptoms checked out immediately.

A pattern that surprised me, though I suppose it shouldn't have, was the persistence of smoking in the families of tobacco widows and disease survivors. I hoped, naively perhaps, to hear of people quitting smoking after watching a parent or relative succumb to tobacco-related disease. In fact, most survivors who had children reported that one or more of those children still smoked. I was surprised, too, when several people in the widow category admitted that they were still smoking, even after seeing what smoking had done to a parent or relative.

I shouldn't have been surprised because, as told in the introduction, my grandmother's death from secondhand smoke did not lead her children to quit. Nor did the lesson of my father's death from lung cancer put an end to smoking

in the family. Clearly, seeing loved ones suffer and die from tobacco-related disease is not enough to induce smokers to quit. This is again testament to the power of addiction to impel self-destructive behavior.

For the widows and survivors in *Smoke Damage,* addiction brought another form of suffering: the anguish of watching loved ones do themselves great harm. When I asked disease survivors and widows if any of their children smoked, the answer "Yes" was always preceded by a sigh. The rest of the answer was often tinged with guilt — as if relaying a story of failure to find the right way to help — and sadness — as if it were just a matter of time before the story ended badly. Both feelings were familiar.

When I started this project, I thought it would be easy to keep my categories distinct. As it turned out, not so. Many of the survivors I talked to had become educators and activists. Many of the people in every category went through a period of tobacco use in their lives. Nearly everyone had lost someone to tobacco-related disease; indeed, the "tobacco widow" category could have subsumed all the others.

The pattern of educators and activists having direct experience with tobacco use, tobacco-related disease, and tobacco politics is worth underscoring. The image of these people as humorless, granola-eating busybodies naive about the hard realities of life is flat wrong. Many of those who appear in *Smoke Damage* knew from personal experience about addiction and tobacco-related disease. And, as noted, nearly all had seen tobacco kill friends and relatives.

As a group, the activists and educators were mainly hardnosed realists when it came to understanding tobacco's appeal, the industry's power, and prospects for change. Their common concern was not running other people's lives, but stopping the tobacco industry from ruining those lives through deceit and manipulation. Given what we now know about the consequences of tobacco use, and about the industry's behavior, it's hard to see this goal as anything but reasonable and moderate.

A number of the disease survivors in *Smoke Damage* were people of my parents' generation, born in the 1930s. Most people in this group claimed that when they started smoking "nobody knew that cigarettes were harmful." While this is not literally true — by the 1950s scientists inside and outside the tobacco industry had already amassed solid evidence that smoking caused disease — it is no doubt true that a teenager starting to smoke in the late 1940s or early 1950s would have had no clue, relative to what we know today, about the health risks of smoking.

Even after the best research of the day was compiled in the 1964 surgeon general's report, it was easier for many smokers to dismiss or ignore the report than to quit smoking. This failure to come to grips with the facts about smoking and disease was abetted by the industry's efforts to sow doubt about the link. It was also a time when warning labels were absent and ads were everywhere. So it's not surprising that people of my parents' generation, speaking of the age when they got hooked, would say that they didn't know any better.

It was more surprising to hear this sort of claim from people of my generation, born in the 1950s. I wondered how anyone who grew up *after* the 1964 surgeon general's report had been widely publicized, *after* packs had warning labels, and *after* anti-smoking ads appeared on national television, could not know that smoking was harmful. I certainly knew it. On the other hand, this abstract knowledge was not enough to deter my own tobacco experimentation.

As noted earlier, most such experimentation occurs during adolescence, before the faculty of foresight is fully developed and prior to any experience of addiction. Still, the rationalist in me wondered how people of my generation — and

subsequent generations — could be undeterred by such an overwhelming and unequivocal body of knowledge about the damage caused by smoking. Is this just a matter of tobacco marketers successfully exploiting adolescent vulnerabilities?

There is more to it, as was suggested to me by several interviewees who were ex-smokers. What they said is that, while they knew smoking wasn't good for them and that it made some people sick, they thought that *if it were really so bad, the government would ban the product and not let it be sold in every drugstore, grocery store, convenience store, and gas station.* Their perception was of a government eager to ban dangerous products. As Rick Stoddard put it, "Contaminated spinach kills three people and they yank it off every shelf in the country. But tobacco can kill 1200 people a day and that's okay?"

Few people are likely to know that 1200 Americans die every day from tobacco-related disease because, as Stoddard also said, it's a non-story from a news perspective, and thus not regularly reported. But everyone knows — and teens surely know — that cigarettes and other tobacco products are available everywhere. The inference that might thus be drawn is the worst possible answer to Stoddard's question: If an otherwise overly protective government allows this stuff to be sold everywhere, then, *yes,* it must sort of be okay, or at least not as bad as some people say it is.

The ready availability of tobacco products is, in other words, an advertising message in itself. Moreover, it's a message that may offset much of what else is said about the health risks associated with tobacco use. It seems fair to suppose that if this is how some of the people in *Smoke Damage* interpreted the message when they were young, then the same thing happens with teens today. The solution, while politically difficult, seems obvious: ban retail sales in any place where children are likely to be present.

Most people in *Smoke Damage* did not hesitate to blame tobacco companies, first and foremost, for the epidemic of tobacco-related disease. A few, however, noted that blame could be placed on a wider range of actors: retailers, as suggested above; advertisers and public relations people; publishers who accept tobacco advertising; unscrupulous lawyers; and captive or cowardly politicians. (To this list I would add cultural and educational institutions, especially universities, that confer legitimacy on a criminal industry by taking its money.) The point is that the epidemic of tobacco-related disease goes on because the industry has many collaborators.

While the deeply entrenched nature of the problem can be discouraging, there are reasons to be optimistic. Good progress has been made in some places — North America, Western Europe — and we know how to build on that progress. It's also clear that the power of the tobacco industry's propaganda is waning. Few people are fooled anymore by the industry's claims that there is doubt about the harmfulness of its products.

The fact that the tobacco industry depends on so many collaborators is also a vulnerability, because these actors can be held accountable through boycotts, protests, public criticism, and elections. This means that everyone who cares about ending the epidemic of tobacco-related disease can do *something,* in his or her own backyard. Even the act of quitting smoking deprives the industry of some of the money on which it depends to keep addicting and killing people.

One final pattern deserves note. When the educators and activists among the people of *Smoke Damage* reflected on their work, they often spoke of the deep satisfaction it brought them. As Pete Hanauer of Americans for Nonsmokers' Rights said, "You couldn't ask for a more rewarding social movement. It's been a labor of love for me." The love, I would say, is for a world with less suffering and better chances for everyone to live a healthy, happy life. As for the labor, it is ongoing and its rewards can be enjoyed by all who lend a hand to make a difference.

Resources

Action on Smoking and Health
http://ash.org/

American Cancer Society
http://www.cancer.org/docroot/home/index.asp

American Heart Association
http://www.heart.org/HEARTORG/

American Legacy Foundation
http://www.legacyforhealth.org/

American Lung Association
http://www.lungusa.org/

Americans for Nonsmokers' Rights
http://www.no-smoke.org/

Campaign for Tobacco-Free Kids
http://www.tobaccofreekids.org/index.php

Centers for Disease Control and Prevention
Office on Smoking and Health
http://www.cdc.gov/tobacco/

QuitlineNC
(Free help to quit smoking)
http://www.quitlinenc.com/
1-800-784-8669

Smokefree.net
http://www.smokefree.net/

Smokefree Restaurants
http://www.tobaccoscam.ucsf.edu/

Stoddard, Rick
http://www.rickstoddard.com/

Tobacco.org
http://www.tobacco.org/

Tobacco Advertising
http://lane.stanford.edu/tobacco/index.html

The Tobacco Atlas
http://www.tobaccoatlas.org/

Tobacco Control (journal)
http://tobaccocontrol.bmj.com/

Tobacco Control Resource Center
(information about the Master Settlement
 Agreement)
http://www.tobacco.neu.edu/tobacco_control/
 resources/msa/

Tobacco Industry Documents
http://tobaccodocuments.org/

Tobacco Journal International
(industry trade journal)
http://www.tobaccojournal.com/

Tobacco Products Liability Project
http://www.tobacco.neu.edu/

University of Michigan Tobacco Research Network
http://www.umtrn.sph.umich.edu/

University of Wisconsin Center for Tobacco Research
 and Intervention
http://www.ctri.wisc.edu/index.html

Wigand, Jeffrey
http://www.jeffreywigand.com/index.php

World Health Organization (Tobacco Free Initiative)
http://www.who.int/tobacco/en/

Acknowledgments

My deepest thanks go to the people who agreed to be interviewed and photographed for this book. For some, this required a courageous willingness to speak about difficult experiences with illness and the death of loved ones. Others gave generously of their time and professional expertise. Everyone extended a degree of trust without which *Smoke Damage* would not exist. This trust has been repaid, I hope, by how I have handled the material given me.

Some of the people interviewed for *Smoke Damage* put me in touch with other participants. For this extra help, my thanks to Joe Cherner, Stanley Rosenblatt, Cliff Douglas, Matt Myers, Jeffrey Wigand, and Maxine Click. Special thanks, too, to Katherine Hampton, who connected me with the speakers from North Carolina S.A.V.E. (Survivors and Victims of Tobacco Empowerment), many of whom appear in this book.

In doing a project like this, one accumulates many debts to friends and colleagues, not all of which are remembered. With apologies, then, to anyone whom I might have forgotten, my thanks to Adam Goldstein, Michael Schulman, Alison Snow Jones, Annie Butzen (a self-described "secondhand smoke nerd"), Aidil Collins, Carol Bowers, David Altman, Tony Kleese, Peg O'Connell, Scott Marlow, Ann Houston Staples, Sally Herndon, and Sherith Pankratz. I am also grateful for encouragement from Doug Harper, Doug Mitchell, and Clyde Edgerton.

At one time I'd thought to include my mother in *Smoke Damage*. She was, after all, the tobacco widow who inspired me to do this book. I decided not to interview her, in part to spare us the awkwardness, but also because I planned to recount in the introduction our family experiences with tobacco-related disease. My mother was, however, my main source of information about family health history. Her help was essential.

At the production stage, this book benefited from the judgment and craft skills of Jane Tenenbaum (designer), Patty Kellison (copy editor), Richard Quinney (publisher of Borderland Books), Terry Emmrich (production manager), and Russell Schwalbe (brother and publishing orchestrator). It was a pleasure to bring *Smoke Damage* into physical existence with this team behind me.

The result of this collective effort is a book that opposes the destruction of health for the sake of profit. I don't think this aspect of *Smoke Damage* can be missed. What might be missed is the flip side: health is precious and should be protected and celebrated. Nothing has reminded me of this more often, through the course of this project and many others, than the love and support I've received from Sherryl Kleinman, partner in sociology, photography, and life.

Michael Schwalbe
Chapel Hill
October, 2010